were captured more than others, such as our families, our houses, trees and pets. But birds are around us all of the time. Unfortunately, as adults we don't notice them as much as we did as children. A child sees them and captures them early in their art. At first, the shapes are simple, and only the most obvious get captured in the art. But as we get older, we add more information into the picture. And once we add some training and practice, look out!

Take a look at the drawings on this page, and see what a difference guidance and training can make. This is the type of result you, too, can expect. By following the step-by-step projects in this book, you will overcome any fears you might have about colored pencil. I had a terrible beginning when I first tried them. Without any guidance, I struggled with them, and my drawings looked like they had been drawn with crayons. But, I never gave up. Now, it is one of my favorite mediums.

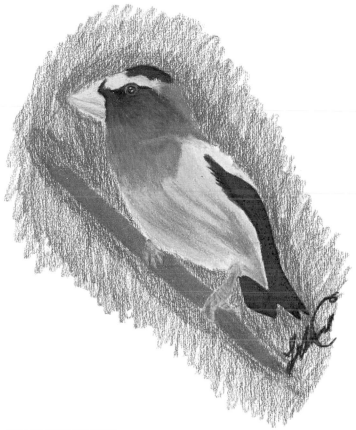

AN ADULT DRAWING

This is a typical rendition of a bird as drawn by an adult. My sixteen -year-old daughter drew it. Although the general features of the bird. such as shape and color have been captured, the artistic realism is lacking.

Drawing by LeAnne Hammond.

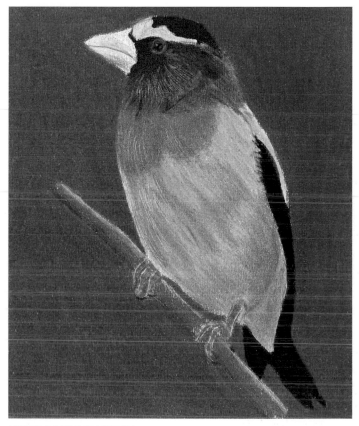

AFTER SOME TRAINING

After I showed her what to look for as an artist, this second drawing takes on more realistic qualities. After LeAnne practiced the colored pencil techniques and then applied them to her drawing, the bird looks wonderful! The realism of the bird has been captured.

Getting Started

Using the Proper Pencils

Each brand of colored pencil has a different appearance when used. Each pencil is made differently to create an unique effect. I can't easily answer which pencil is "the best," or which one I like the most. It really depends on the final outcome and the "look" I want my work to have. Rarely will I use just one brand of pencil to complete a project. Any one of them alone is somewhat limited. I have found that by using a combination of pencils, I can create more variety in my techniques. This enables me to achieve the look I'm trying to accomplish. The following is an overview of the six types of pencils I like the most.

PRISMACOLOR PENCILS

Prismacolor pencils have a thick, soft wax-based lead that provides a heavy application of color. They are opaque and will completely cover the paper surface. They are excellent for achieving smooth, shiny surfaces and brilliant colors. The colors can be easily blended to produce an almost "painted" appearance to your work. They come in a huge selection of colors: 120 or more.

VERITHIN PENCILS

Verithins also have wax-based lead, but have a harder, thinner lead than the Prismacolors. Because of their less waxy consistency, they can be sharp-

ened to a very fine point. They are compatible with Prismacolor but are more limited in their color range, which is thirty-six. I use Verithins whenever I want the paper to show through because they cannot build up to a heavy coverage. They can give you

very sharp, crisp lines. They are good for layering colors without the colors mixing together. The Prismacolors can give your work a painted appearance; the Verithins give your work more of a "drawn" look.

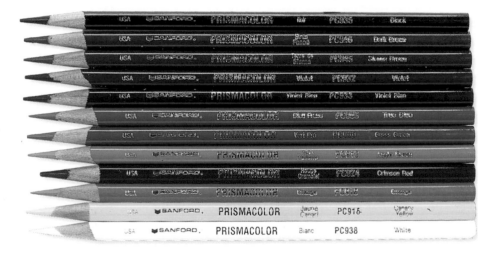

Prismacolor pencils.

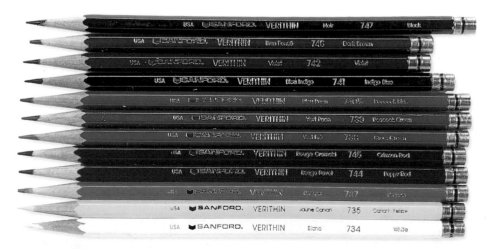

Verithin pencils.

Drawing in Color

BIRDS

Lee Hammond

NORTH LIGHT BOOKS
CINCINNATI, OHIO
www.artistsnetwork.com

Acknowledgments

Every time I begin the manuscript for a new book, I am amazed by how lucky I am. I remember what seems like yesterday, saying to myself, "Someday I sure would like to have a book published." That dream obviously came true in a big way, with this book being number twelve. It reminds me of how much I appreciate the endless opportunity that North Light Books has provided me. I will never take this opportunity for granted.

Thank you Greg Albert for always lending an ear to a complaint or an idea—but most of all for always having faith in me. Thanks to Michael Berger for his wonderful editing and patience.

Also, I would like to thank my wonderful students, who sometimes go on the back burner in order for me to meet a deadline.

And, most of all, a huge thanks to my family, who has somehow managed to survive it all. I love you!

A special note: Many of the pictures taken for this book were shot at the Carolina Raptor Center, in Charlotte, North Carolina. I want to thank everyone there for being so helpful. It was a special treat spending the day with you.

Drawing in Color: Birds Copyright © 2001 by Lee Hammond. Manufactured in China. All rights reserved. No part of this book may be reproduced in any form or by any electronic or mechanical means including information storage and retrieval systems without permission in writing from the publisher, except by a reviewer, who may quote brief passages in a review. Published by North Light Books, an imprint of F&W Publications, Inc., 4700 East Galbraith Road, Cincinnati, Ohio 45236. (800) 289-0963. First edition.

Other fine North Light Books are available from your local bookstore, art supply store or direct from the publisher.

06 05 04 03 02 6 5 4 3 2

Library of Congress Cataloging-in-Publication Data

Hammond, Lee 1957-
 Birds / Lee Hammond.
 p. cm. -- (Drawing in Color)
 Includes index.
 ISBN 1-58180-149-1 (pbk. : alk. paper)
 1. Birds in art. 2. Colored pencil drawing--Technique. I. Title. II Series.

NC782 .H35 2001
743.6'8--dc21 2001030902

Editor: Michael Berger
Production editor: Bethe Ferguson
Production coordinator: Mark Griffin

METRIC CONVERSION CHART		
to convert	to	multiply by
Inches	Centimeters	2.54
Centimeters	Inches	0.4
Feet	Centimeters	30.5
Centimeters	Feet	0.03
Yards	Meters	0.9
Meters	Yards	1.1
Sq. Inches	Sq. Centimeters	6.45
Sq. Centimeters	Sq. Inches	0.16
Sq. Feet	Sq. Meters	0.09
Sq. Meters	Sq. Feet	10.8
Sq. Yards	Sq. Meters	0.8
Sq. Meters	Sq. Yards	1.2
Pounds	Kilograms	0.45
Kilograms	Pounds	2.2
Ounces	Grams	28.4
Grams	Ounces	0.04

This book is fondly dedicated to two of my closest friends.

I would like to say a resounding thank you to Laura Tiedt for her undying loyalty and friendship over the last decade. If not for her, my life would not be nearly as meaningful as it is now. Through her kind words and huge heart, she has proven what true friendship is all about.

And I would also like to thank Lanny Arnett for all of his help. He has taken classes from me longer than anyone else—almost twenty years—and has been my right-hand-man through it all. With his constant support and unshakable confidence in me, my career has been able to flourish. Thank you for always being there, to pick up where I leave off.

About the Author

Polly "Lee" Hammond is an illustrator and art instructor from the Kansas City area. She owns and operates the Midwest School of Illustration and Fine Art, Inc., where she teaches realistic drawing and painting. In the year 2001, the name of her business will change to Take it to Art.*

She was raised and educated in Lincoln, Nebraska, and built her career in illustration and teaching in Kansas City. Although she has lived all over the country, she will always consider Kansas City home.

Lee has been an author with North Light Books since 1994. She also writes and illustrates articles for other publications, such as *Artist's Magazine*.

Lee is continuing to develop new art instruction books for North Light, and is expanding her career into children's books, which she will also illustrate. Fine art and limited edition prints of her work will soon be offered.

Lee resides in Overland Park, Kansas, along with her family.

Note: You may contact Lee via e-mail at Pollylee@aol.com or visit her Web site at http://LeeHammond.com

* Take it to Art is a registered trademark for Lee Hammond.

Table of Contents

Foreword

Since childhood, I have had a fascination with colorful things. It was surely due to the aspiring artist within, begging to be set free. I remember my first true artistic desire being motivated by an episode of *Captain Kangaroo.* Crayola Crayons sponsored that show, and The Captain was holding up very realistic drawings done with them. My eyes opened wide when I saw one particular drawing. It was a rainbow trout, with all of its vibrant hues. It looked just like a photo-graph. I couldn't believe it was drawn with crayons, and it created a burning desire to learn. I promised myself on that very day, at the ripe age of five, that someday I would draw like that!

Well, that day has come, and I couldn't be happier or more ful-filled. It was an answer to my prayers. But it was also the result of a lot of hard work.

As I drew the illustrations for this book, I was once again filled with the childlike joy of producing such magnificent colors. I am sure that you will enjoy the same type of feeling as you learn to draw birds. Like me, you will need a lot of prac-tice and dedication to achieve the realistic work that you are seeking. I am a testimonial to what can happen if you work hard. I didn't have much guidance, and taught myself these techniques. Allow me to guide you, and you will be drawing great-look-ing birds in no time.

Introduction

Welcome to the wonderful world of drawing birds. Few subject matters in this world will offer you such a wide array of colors, shapes and sizes. Hundreds of books have been written about these magnificent creatures. There are thousands of varieties of birds from which you can choose to draw. They hold for us an endless opportunity for creating masterpieces.

Colored pencil is a wonderful tool for capturing them. No other medium has the versatility to create all of the colors and textures so realistically. Let me guide you to some of the most beautiful drawings you'll ever create.

You'll notice that there are quite a few parrots in this book. That is because my birth name is Polly. (I shortened it to Lee due to the wise-cracks growing up! You guessed it—"Polly want a cracker?")

Even though I didn't enjoy the name much, I've had a fondness for parrots all of my life. I hope you will enjoy looking at them as much as I enjoy drawing them.

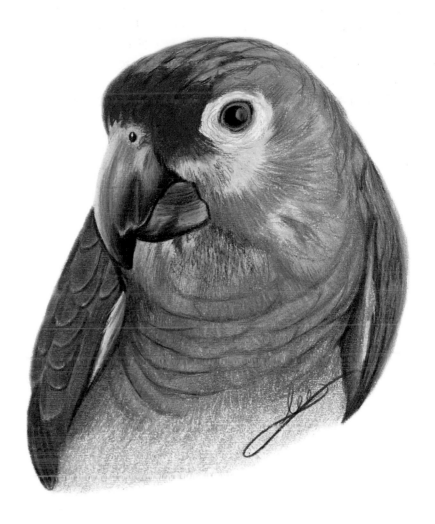

You Can Do It!

Everyone has doubts about their creative abilities at first. Trying something new is never easy. You have purchased this book because you like birds and have a desire to draw them realistically. That is exactly what it will teach you to do.

This book is not a "bird book" in the true sense of the phrase. It will not describe the various species and where they can be found. It will not tell you their particular diets, mating rituals or the origins of the species. Any field guide can tell you that information.

This book is designed to make you look at birds in a different way. An artist must see things differently. You must disassociate with much of what your subject "is" and see it for "what it looks like." This is the process for drawing everything, not just birds.

I am fortunate in the respect that I am not only an artist but also a photographer. The photos in this book are my own. Having this skill allows me to first capture on film the subject I intend to draw. For those of you who do not excel in photography, I recommend practicing drawing from magazine photos. There are many interesting ones available.

There is also an excellent book available from North Light, called the *Artist's Photo Reference: Birds*, by Bart Rulon, that is a wonderful source of drawing material.

It is imperative that you learn to see the "shapes" of what you are drawing. The shapes of a bird are very recognizable. We usually think of birds as being perched on a limb, or soaring in flight, wings outstretched. Seeing these obvious

shapes is the first step to drawing realistic birds.

As children, even at an early age, we begin to capture our world with pictures. We can all remember having crayons in hand, drawing what was most familiar. Certain subjects

BIRD SILHOUETTES
The two silhouettes here show the obvious outlines of both a bird in flight and a bird perched on a limb.

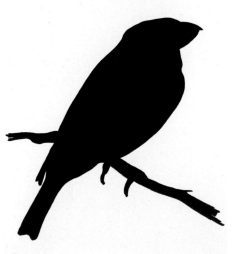

COL-ERASE PENCILS

Unlike Prismacolor and Verithin, Col-erase pencils can be easily erased. They can also be blended with a stump or tortillion, giving them the look of pastel. Although these pencils have a limited palette of colors (only twenty-four), the ability to blend colors makes them quite versatile. They also can be sharpened into a fine point, but due to their powdery consistency, it is hard to achieve extreme darks. Left unsealed, without applying a fixative, they look like pastel. Spray them with fixative, and they can resemble watercolor.

STUDIO PENCILS

Studio pencils, by Derwent, are somewhat like a composite of the other brands. They are a clay-based pencil with a range of seventy-two colors. Applied heavily, they can create deep, dark hues. Applied lightly, they can be blended with a tortillion. They also have a sister pencil called the Artists line, which is the same formulation with a bigger lead diameter. I use the Studio line because I prefer a sharper point. Also, because it is clay based, it will not build up color as well as Prismacolor and will give more of a matte (nonglossy) finish.

Col-erase pencils.

Studio pencils.

WATERCOLOR PENCILS

Watercolor pencils are unique artistic tools that can be used to combine the techniques of drawing and painting. They contain actual watercolor pigment put into a pencil form. They can be used to draw with, just like any other colored pencil. But with the application of a little water and a paintbrush, the pigment dissolves into paint, changing the look entirely. These are a fun break from traditional colored pencils.

NEGRO PENCILS

Using the Negro clay-based black pencil is an excellent way to achieve deep, rich black in your work without a hazy wax buildup. This is the blackest pigment I've ever found in a colored pencil. It comes in five degrees of hardness, ranging from soft (1) to hard (5).

Watercolor pencils.

Negro pencils.

Tools of the Trade

As with anything we do, the quality of our colored pencil artwork is determined by the quality of the tools we employ for the job. The following is a list of supplies you will need to succeed.

PAPER

The paper you use with colored pencils is critical to your success. There are many fine papers on the market today. You have hundreds of options of sizes, colors and textures. As you try various types, you will undoubtedly develop your personal favorites.

Before I will even try a paper for colored pencil, I always check the weight. Although there are many beautiful papers available, I feel many of them are just too thin to work with. I learned this the hard way, after doing a beautiful drawing of my daughter only to have the paper buckle when I picked it up. The crease formed was permanent, and no amount of framing kept my eye from focusing on it first. From that point on, I never used a paper that could easily bend when picked up. The more rigid, the better! Strathmore has many papers that I use often. The following is a list of

Prismacolor pencils on mat board.

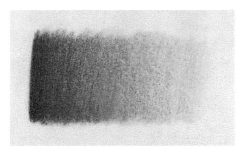
Prismacolor pencils on suede board.

Strathmore Renewal paper has soft colors with the look of tiny fibers in it.

Artagain, also by Strathmore, has a speckled appearance and deeper colors. Both have a smooth surface.

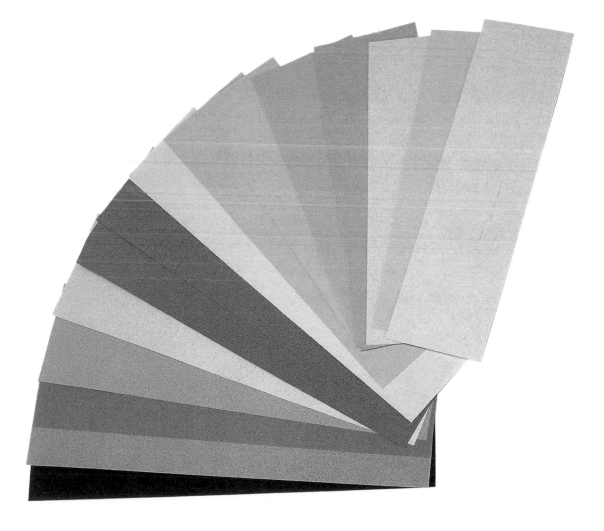

the ones I personally like to use the most and recommend to my students.

Artagain—Artagain is a recycled paper by Strathmore that has somewhat of a flannel appearance to it. This 60-lb. (130gsm) cover-weight paper comes in a good variety of colors, dusty as well as black and white. Although it has a speckled appearance, its surface has no noticeable texture. It is available in both pads and single sheets for larger projects.

Renewal—Renewal is another Strathmore paper, very similar to Artagain, but it has the look of fibers in it instead of speckles. I like it for its soft earth tones.

Crescent Mat Board—My personal favorite is Crescent because of the firmness of the board. It is already rigid and doesn't have to be taped down to a drawing board. This makes it very easy to transport in a portfolio. Its wide range of colors and textures is extremely attractive. Not only do I match the color to the subject I am drawing, I will often use the same color of mat board when framing the piece to make it color coordinated.

Crescent Suede Board—Crescent Suede Board is another one of my favorites.

It has a surface like suede or velveteen. I have developed a technique using Prismacolor that makes it look like pastel when applied to this fuzzy surface.

PENCIL SHARPENERS

Pencil sharpeners are very important with colored pencils. Later in the book, you will see how many of the techniques require a very sharp point at all times. I prefer an electric sharpener, or a battery-operated one when traveling. A handheld sharpener requires a twisting motion of the arm. This is usually what breaks off the pencil points. The motor-driven sharpeners allow you to insert the pencil straight on, reducing breakage. If you still prefer a handheld sharpener, spend the extra money for a good metal one, with replacement blades.

ERASERS

I suggest that you have three different erasers to use with colored pencil: a kneaded eraser, a Pink Pearl eraser and a typewriter eraser. Although colored pencil is very difficult, if not impossible, to completely erase (except for Col-erase), the erasers can be used to soften colors as you draw.

The kneaded eraser is like a squishy piece of rubber, good for

removing your initial line drawing as you work. It is also good for lifting highlight areas when using the Col-erase pencils. (I'll show you later.) Because of its soft, pliable feel, it will not damage or rough up your paper surface.

The Pink Pearl eraser is a good eraser for general cleaning. I use it the most when I am cleaning large areas, such as backgrounds. It, too, is fairly easy on the paper surface.

The typewriter eraser looks like a pencil with a little brush on the end of it. It is a highly abrasive eraser, good for removing stubborn marks from the paper. It can also be used to get into tight places or to create clean edges. However, great care must be taken when using this eraser, because it can easily damage the paper and leave a hole.

MECHANICAL PENCIL

I always use a mechanical pencil for my initial line drawing. Because the lines are so light, unlike ordinary drawing pencils, they are easily removed with the kneaded eraser. As you work, replace the graphite lines with color.

TORTILLIONS

Tortillions are cones of spiral-wound paper. They are used to blend after

NOTE—
When a fixative is used on colored pencils that have been blended with a tortillion, the pigment can seem to melt into a watercolor appearance. The colors will appear much brighter and darker. Leave unsprayed.

you have applied the colored pencil to the paper. I use them only with Col-erase and Studio pencils. Prismacolor is much too waxy for this technique. Verithins work somewhat but don't blend as evenly as the clay-based pencils.

ACETATE GRAPHS

Acetate graphs are overlays to place over your photo reference. They have grid patterns on them that divide your picture into even increments, making it easier to draw accurately. I use them in both 1" (2cm) and ½" (1cm) divisions. They are easy to make by using a permanent marker on a report cover. You can also draw one on paper and have it copied to a transparency on a copy machine.

TEMPLATES

Templates are stencils that are used to obtain perfect circles in your drawing. I always use one when drawing eyes to get the pupils and irises accurate.

MAGAZINES

The best source for drawing material is magazines. I tear out pictures of every subject and categorize them into different bins for easy reference. When you are learning to draw, magazines can provide a wealth of sub-ject matter. When drawing people, there is nothing better than glamour magazines.

CRAFT KNIVES

Craft knives are not just for cutting things; they can actually be used as drawing tools. When using Prismacolor, I use the edge of the knife to gently scrape away color to create texture such as hair or fur, a knife can also be used to remove unwanted specks that may appear in your work. As you can probably imagine, it is important to take care with this approach to avoid damaging the paper surface.

FIXATIVES

The type of spray that you use to fix your drawing depends again on the look you want your piece to ultimately have. I use two different types of finishing sprays, each one with its own characteristics.

Workable fixative—The most common of the sprays, the workable fixative is undetectable when applied. The term "workable" means that you can continue drawing, after you have applied the spray. Experience has taught me that this is more true for graphite and charcoal than it is for colored pencil. I have found fixative to actually behave as a resist. I use it whenever I don't want the appearance of my work to change. When using Prismacolor, the wax of the pencil will rise to the surface, making the colors appear cloudy and dull. Workable fixative will stop this "blooming" effect and make the colors true again.

Damar varnish—I use this spray when I want a high-gloss shine applied to my Prismacolor drawings. It will give the drawing the look of an oil painting and make the colors seem shiny and vivid. (Its primary use is to seal oil paintings.) I will often use this when drawing fruit and flowers, but it will make a portrait beautiful also.

HORSE HAIR DRAFTING BRUSH

This is an essential tool when you are drawing, but even more so when using colored pencil. Colored pencil, particularly Prismacolor, will leave specks of debris as you work. Left on the paper, they can create nasty smudges that are hard to erase later. Brushing them with your hand can make it worse, and blowing them off will create moisture on your paper, which will leave spots. A drafting brush gently cleans your work area without smudging your art.

The Different "Looks" of Colored Pencils

Drawing in colored pencil is somewhat deceptive terminology. It is not that simple. Each brand of pencil has its unique look, produces a different effect and requires a different technique. There are many types of colored pencils, each with its own formulation. When deciding which pencil to use, you must decide which look you want your artwork to have and ask yourself which pencil will help create that look. Look at the examples here and on the following pages. Each of these drawings has its own look. Some are bold and bright; others are soft and delicate.

Throughout this book we will explore four different brands of pencils and many techniques designed to give your artwork the most realism possible. When you look at the samples shown on the next few pages, notice how each has a distinct difference in its look due to the specific brand of pencil used. Before I begin a piece, I analyze the characteristics of it and decide which pencil creates the look I am intending. And although all of these drawings may look alike at first glance, close observation will demonstrate their unique qualities.

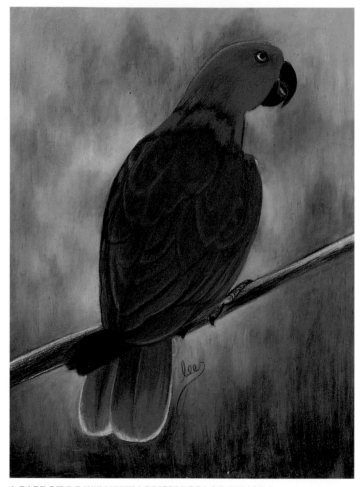

A PARROT DRAWN WITH PRISMACOLOR PENCILS
This drawing of a parrot has been created with Prismacolor pencils. It is the only pencil thick and waxy enough to create these bright, vivid hues. Look closely at the parrot's feathers. The fine lines were "scraped" in with a craft knife. Then the drawing was sprayed with a gloss Damar varnish to make it shiny. Because of the wax content of these pencils, you may see a wax haze or bloom occur while working. Spraying the drawing with a fixative at completion will remove the haze.

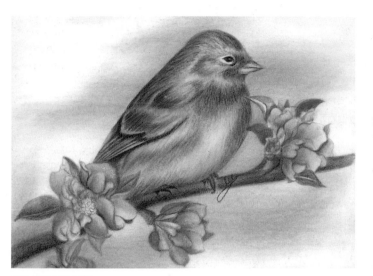

VELOUR PAPER

This is an example of how Prismacolor pencils look when applied to a fuzzy paper called velour. The pencil now has the look of pastel instead of the bright, built-up color we saw in the illustration before. This paper is very susceptible to lint and debris. A piece of tape lightly pressed to the surface can help remove unwanted particles.

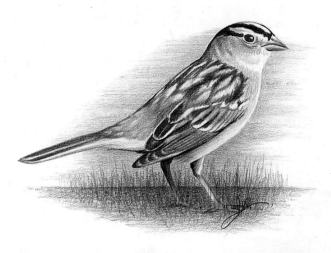

VERITHIN PENCILS

Look closely at this drawing and you can see the grainy texture this pencil provides. The paper texture shows through. Verithin pencils are good for drawing textured surfaces and subjects requiring thin lines. It is very important to maintain a sharp point on these pencils at all times while working.

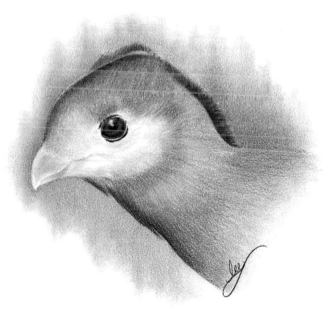

STUDIO PENCILS

This drawing has a soft, blended appearance. Studio pencils have a clay base, which makes them easily blended with a tortillion. Studio pencils can also produce dark tones, which make them very versatile. You can see both techniques used in this drawing. Be sure to use clean tortillions when changing colors. It is important to then keep them separated according to the colors they were used for.

WATERCOLOR PENCILS

The finished product looks more like a painting than a drawing. Watercolor pencils can be used both wet and dry for a variety of effects.

Different Brands of Colored Pencils

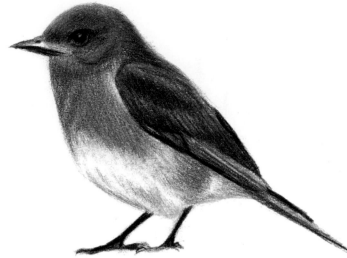

PRISMACOLOR
This bluebird was drawn with Prismacolor pencils. The thick, waxy lead of this pencil completely covers the surface of the paper. It gives the drawing a smooth look.

VERITHIN
This bluebird was drawn with Verithin pencils. The thin, hard lead of this pencil gives the drawing a grainier look than the one seen before.

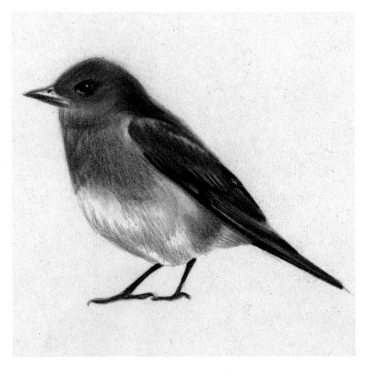

PRISMACOLOR ON SUEDE BOARD
This bluebird was drawn with Prismacolor pencils, but this time on suede board. The look is very soft, much like a pastel drawing. It doesn't even resemble the look of the first drawing done with the same pencils!

STUDIO

This bluebird was drawn with the Studio pencils. Because the tones are blended with a tortillion, it has a softer look to it than the previous two drawings.

WATERCOLOR

This bluebird was done with Watercolor pencils. It looks much more like a painting than a drawing.

Technique

As with any technique, there is a right way and a wrong way to proceed. The most common complaint I hear about drawings made with colored pencil is that they can look like crayon drawings instead of a nice piece of art. This is just a misunderstanding of how the medium should be used. It is very important to learn how to apply the pencils properly.

The first example below looks very much like crayon. The rough, uncontrolled fashion in which it has been applied appears childish.

The second example looks much better. The pencil lines have been applied smoothly, so the distinct lines are not evident. The result is a smooth gradation of tone from dark to light, with no choppiness. This type of control in application leads to good artwork.

A scribbled approach when applying colored pencil will produce a look similar to crayon.

Applying color using controlled pencil lines produces an even gradation of tone.

COLOR

A good understanding of colors and how they work is essential to drawing. It all begins with the color wheel, which illustrates how colors relate to one another.

The basic groups of colors are primary and secondary colors. Another categorization is warm and cool colors. A third is complementary colors. Within these classifications, you will encounter shades and tints.

There are three primary colors: red, yellow and blue. They are pure colors. Mixing these colors in different combinations creates all the other colors. Mixing two primary colors makes a secondary color; for instance, red mixed with yellow makes orange. Secondary colors can be found in between the primary colors on the color wheel.

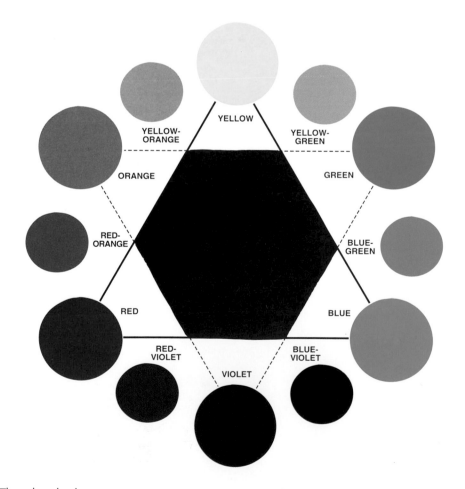

The color wheel.

The warm colors consist of yellow, yellow-orange, orange, red-orange, red and red-violet. The cool colors are violet, blue-violet, blue, blue-green, green and yellow-green.

Complementary colors are oppo sites on the color wheel; for example, red is the opposite of green. Opposite colors can be used in many ways. Mixed, complements become gray. For shadows it is always better to mix a color with its opposite, rather than adding black.

An opposite color can also be used to "complement" a color, or make it stand out; for instance, to make the color red stand out, place green next to it. This is the most frequent color theory found when working with flowers and nature. Because almost all stems and leaves are green and many flowers are red or pink, the flowers have a very natural way of standing out.

Shades and tints are also important. A shade is a darker version of itself. A tint, on the other hand, is a lighter version. Shades and tints are the result of light and shadow.

There are two more terms that apply to color: hue and intensity. Hue is color applied lightly; intensity is color applied brightly. Unlike shades and tints, which use other colors to change the way they appear, hue and intensity apply to the overall concentration of color.

Experimenting with color is fascinating. As you proceed through this book, you will see many examples of using color creatively.

A value scale made with warm colors (red, orange and yellow).

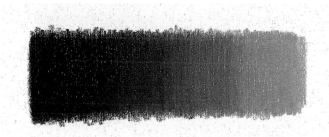

A value scale made with cool colors (violet, blue and green).

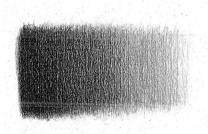

A value scale made with complementary (opposite) colors (blue and orange).

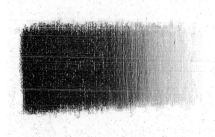

Shades and tints of red, as seen on a value scale. The middle section is the true color. Everything on the left is a shade; everything on the right is a tint.

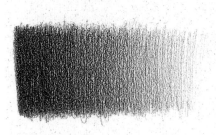

Greater intensity is achieved by increasing the hue.

The Simple Egg

So what comes first, the chicken or the egg? It is an age-old question. But, for us artists, the answer is easy. The egg! It is the overall shape most obviously seen within the form of a bird, and shape is everything. In fact, the simple-looking egg may be the most important drawing in the whole book. It contains every element necessary for creating a realistic-looking drawing of a bird.

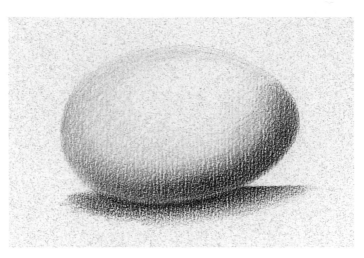

THE MOST COMMON SHAPE
The egg is the most common basic shape seen within the form of a bird.

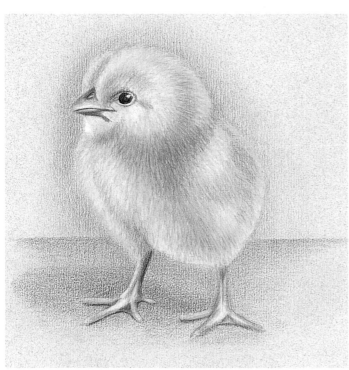

Look for the egg shapes within the form of this chick.

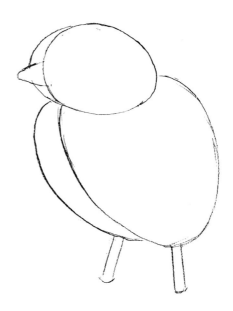

This line drawing shows how the simple egg shape is repeated four times to create a small chick. Notice how the body of the chick is thick and appears divided down the middle. For this reason, it is better to use four egg shapes, rather than two, when creating it.

The Five Elements of Shading

Because it is important to fully understand what it takes to create depth and realism in your work, I begin all of my books with the same information: the five elements of shading and practice exercises of the sphere. The five elements of shading can be found in every three-dimensional shape, including the little egg and the chick. The five elements of shading are as follows (listed in order from darkest to lightest):

1. **Cast shadow.** This is the darkest part of your drawing. It is underneath the sphere, where no light can reach. It gradually gets lighter as it moves away from the sphere.
2. **Shadow edge.** This is where the sphere curves and the rounded surface moves away from the light. It is not the edge of the sphere, but is inside, parallel to the edge.
3. **Halftone area.** This is the true color of the sphere, unaffected by either shadows or strong light. It is

found between the shadow edge and the full light area.
4. **Reflected light.** This is the light edge seen along the rim of the sphere. This is the most important element to include in your drawing to illustrate the roundness of the surface.
5. **Full light.** This is where the light is hitting the sphere at its strongest point.

Look at the egg again. Can you see all of these elements there?

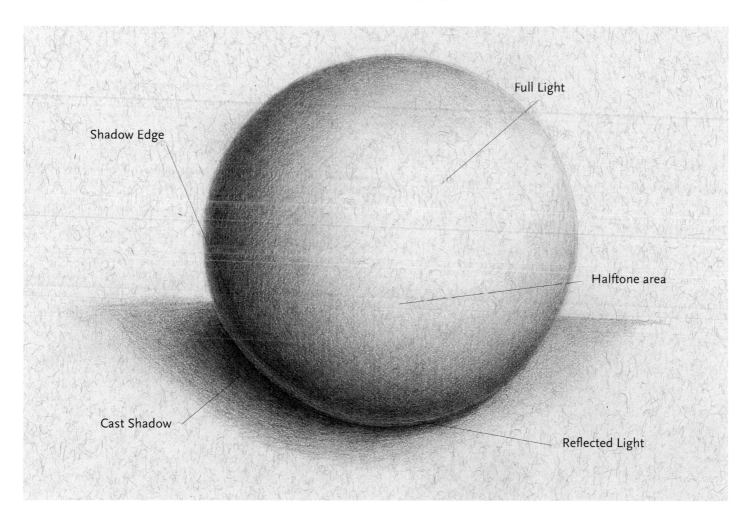

Full Light

Shadow Edge

Halftone area

Cast Shadow

Reflected Light

Drawing a Sphere Step-by-Step

Using this step-by-step example, practice drawing the sphere. I have used the Verithin pencils for this exercise. After drawing the sphere, practice drawing the egg also. Apply the five elements of shading as well. The more of this you do now, the better your drawings will be later.

COLORS USED

Dark Brown, Poppy Red and Canary Yellow.

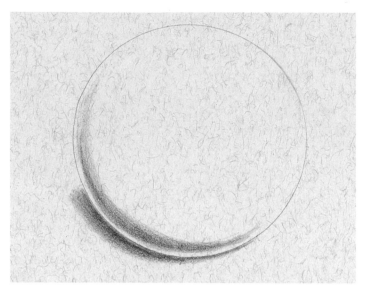

1 Trace around a circular object, or use a template to give yourself a round outline. With Dark Brown, add the cast shadow below the sphere. Also add the shadow edge. Remember, this does not go to the edge of the sphere, but is inside, parallel to the edge. The space between will become the reflected light area.

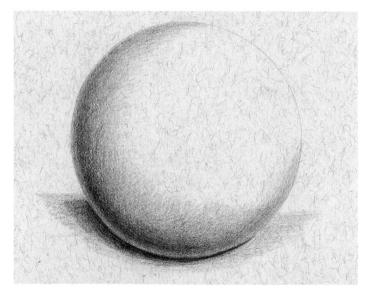

2 Add Poppy Red, overlapping the Dark Brown already there. You are now creating the halftone area. Work up gradually to the light area. Place some Poppy Red below the sphere, over the cast shadow and around to the other side. This gives you the illusion of a tabletop.

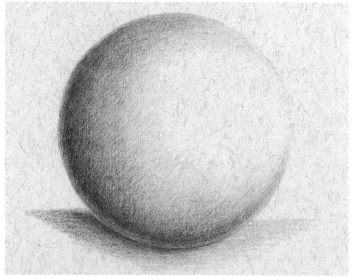

3 With Canary Yellow, lightly overlap all of the colors already there. Lighten your touch, and gradually fade into the color of the paper in the full light area.

Drawing an Egg Step-by-Step

For additional practice, use this example of a step-by-step egg. It has been drawn with the Studio pencils and blended with a tortillion. It has a smoother look to it than the sphere exercise before, doesn't it?

<div>

COLORS USED

Chocolate Brown,

</div>

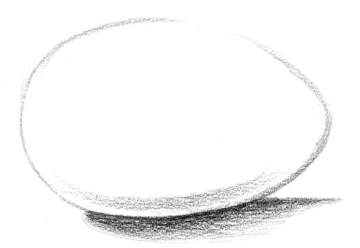

1 Lightly sketch an outline of an egg with your mechanical pencil. Go over it lightly with a Chocolate Brown Studio pencil. Place the cast shadow below the egg. Lightly apply the shadow edge, leaving room for the reflected light. The light is coming from the front on this example, so the shadow areas are off to the sides.

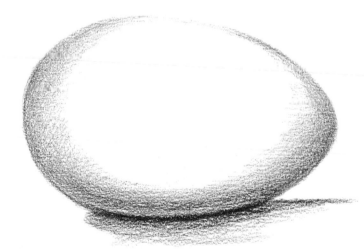

2 Build your tone with the Chocolate Brown, until it looks like mine. This area is the halftone. Lighten your touch as you move toward the full light area.

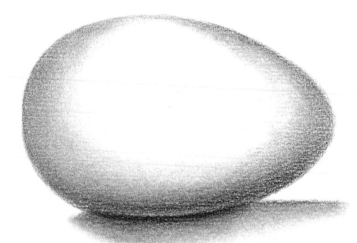

3 With a tortillion, smooth the tones. Begin in the dark areas and work toward the lighter ones, lightening your touch as you go. Can you see how the color changes when blended? It takes on a warmer appearance.

Basic Shapes for Drawing Birds

The following are all of the basic shapes seen when drawing birds. Each one has had the five elements of shading applied, giving them the illusion of form and realism. Each of these shapes should be drawn and practiced over and over, until the process becomes second nature to you.

As you analyze these shapes, try to think of where each of them would be found in the shape of a bird and its surroundings. Think of other subject matter as well, and you will see the importance of including these forms in your artwork.

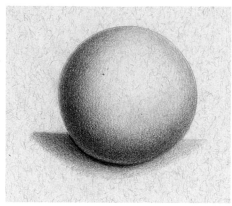

THE SPHERE
Look for the five elements of shading here.

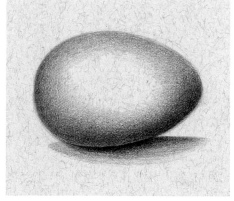

THE EGG
This can be seen in the shape of a bird's head, and also in the body.

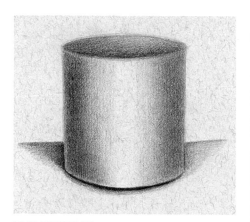

THE CYLINDER
This shape can be seen in the neck area of a bird, and also in the trunks of trees.

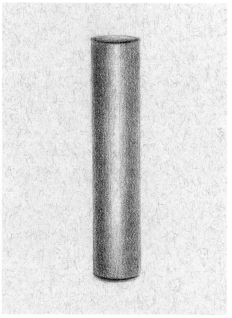

THE LONG CYLINDER
This can be found in the legs of a bird. It also can be found in the necks of long-necked birds, such as ostriches and swans. The small limbs and branches of a tree will also be made up of this shape.

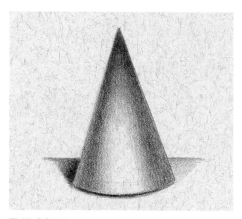

THE CONE
This can be seen in the shape of bird's beak.

NOTE—
Refer back to the illustration of the chick, on page 22, and look for these shapes.

These two photographs clearly illustrate how the egg shape is seen within the body structure of a bird. The rhea and the flamingo have similar body shapes and necks. Even the shadow under the emu is egg shaped. It is important to identify these basic shapes early, before you begin your drawing.

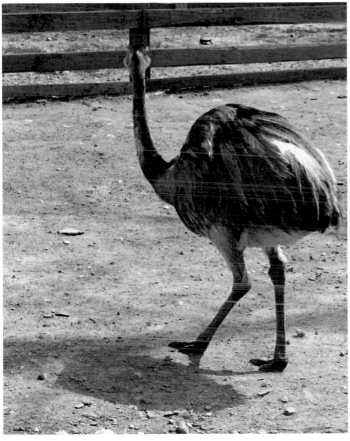

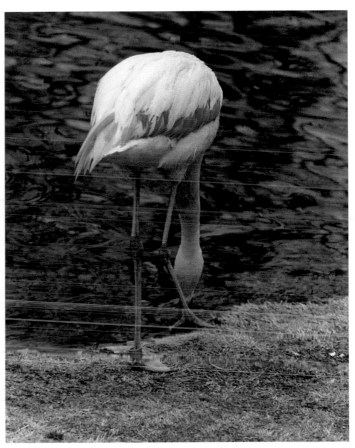

PHOTOGRAPH OF AN RHEA
The rhea is similar in appearance to the emu; its body is an obvious egg shape. The shadow is egg shaped as well. Look for the long cylinder in the shape of the neck and the legs.

PHOTOGRAPH OF A FLAMINGO
The same shapes can be seen in this bird. The flamingo has much thinner legs than the emu.

Graphing

To draw anything with a high level of realism, it is very important for the shapes to be accurate. However, being able to see shapes accurately and translate them onto paper is not easy. While freehand drawing is often fun and enjoyable, it is rarely accurate—at least without investing a large amount of time in the process. There are some methods that will help you be truly accurate.

We will be working from photographs. The techniques you will learn here can then be used later when drawing from life. Working with photographs affords us many luxuries. It allows us time to really study the subject we are drawing, without fear of the position and lighting changing. It gives us the ability to edit the picture by enhancing certain elements while eliminating others altogether. But most important of all, it makes it possible for us to graph, or project, our beginning outline. This will give us an accurate foundation for our drawing.

While some artists will argue that graphing or obtaining an outline with the use of an opaque projector is "cheating," I couldn't disagree more. I teach my students both methods as a means of training their eyes to see shapes accurately. Being self-taught, this is one of the ways I honed my skills. I attribute my ability to freehand with a high degree of accuracy today to using the graph and projector repeatedly early in my training. This repetition of capturing shapes and seeing how one shape connects to another measurably increases your ability to freehand accurately.

An opaque projector is a machine that uses a lightbulb to project the image of a photograph down onto the surface of your drawing paper. Often, I will check a student's freehand ability with the projector. I take the photograph the student is drawing from and place it in the projector. I then project the image *over* the freehand drawing. By lining it up, the same size, *over* the drawing, all of the inaccuracies show up. The student then can analyze the errors and make the appropriate corrections.

The ability to see shapes is due to our "perception." Often, we will make the same types of mistakes in the accu-racy of our drawings, over and over again, without even realizing it. This is due to drawing from memory instead of really looking at our reference for the shapes. The graph and the projector force us to see things a different way. This process makes us perceive things as shapes alone. The graph helps us view the shapes accurately by dividing the image into smaller, more manageable shapes.

An empty graph of 1-inch (2cm) squares. Enlarge template 227% to return to full size.

> NOTE—
> To draw an image larger, make the squares on your drawing paper larger than 1-inch (2cm). You can reduce the size of something with this method also, by making the squares on your paper *smaller* than those on the photo. As long as the boxes are square, the shapes will be proportional.

Drawing From Graphed Photos—Red-Tailed Hawk

To draw this red-tailed hawk accurately, I had the photo enlarged as a color copy. I then drew a 1-inch (2 cm) grid over the top of it with a marker—the grid pattern helps reduce the photo's subject matter into more manageable, easy-to-see shapes. If you have a large photograph, and do not want to mark on it, you can apply a transparent grid overlay on top of it.

To draw from a graphed photograph, first very lightly apply a graph onto your drawing paper with a mechanical pencil. Apply the lines as light as possible, since they will need to be erased later.

Concentrate on seeing things as just shapes. Draw the shapes you see within each square of the graphed photograph as close to the size, shape and placement as possible. Turn your paper upside down to make the image less recognizable—this will prevent you from drawing what a bird looks like from memory.

Look at the small details of the hawk, such as the feathers, colors and markings. See these areas as shapes as well, and include them in your line drawing. When you are finished, your drawing will be a simple outline of the major shapes, and will resemble the look of a map. That is exactly what this is—a map to guide you through your rendering.

Finally, take a kneaded eraser and gently remove the graph lines. This drawing will be used later on page 50 to practice drawing with Verithin pencils. To use it for the finished drawing later, it should be drawn on a sheet of Arctic White mat board no. 3297.

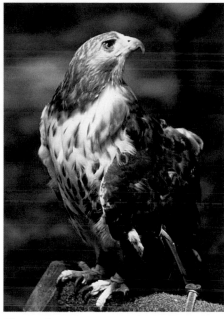

Photo reference.

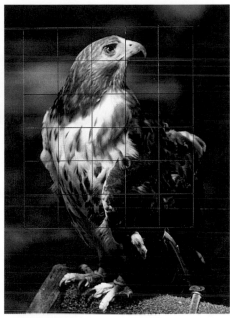

A copy of the photograph with a 1-inch (2cm) graph applied.

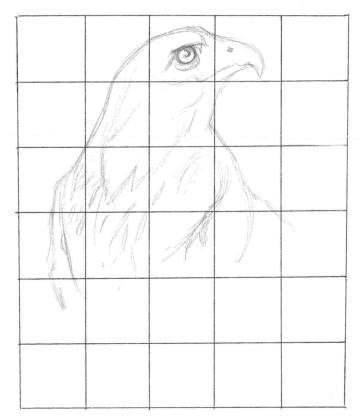

An accurate line drawing of the photo that has been drawn within a grid. The same size boxes were used. This will be used for a project on page 50.

American Kestrel

The following examples provide photographs for you to draw from. They not only will be excellent practice for your graphing skills, they will be used later in the book as full-color step-by-step projects. Be sure to use the paper recommended, because it is important to the final look of the drawing.

Start this drawing of the kestrel by lightly drawing a grid of 1-inch (2cm) boxes on a piece of banana fiber or other speckled drawing paper. Remember: Draw this grid as lightly as possible. You do not want to damage the surface of the paper when you erase it later. Use the graphed photo as a guide, and draw the shapes of the falcon within each square as accurately as possible.

Your line drawing should look just like mine when you are finished. Once again, I was sure to include the small details of the feathers, colors and markings. You will use this sketch for the Verithin colored pencils project on page 52.

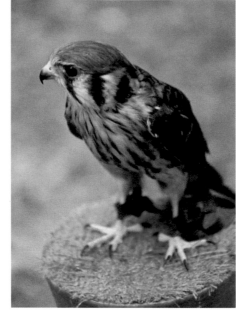

Photo reference

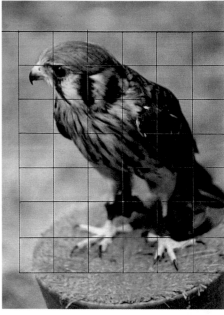

A copy of the photograph with a 1-inch (2cm) graph applied.

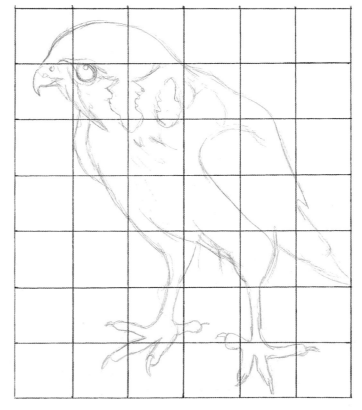

An accurate line drawing of the photo that has been drawn within a grid. The same size boxes were used. This will be used for a project on page 52.

NOTE—
Graphing can be used to enlarge or reduce the size of your subject. By placing larger squares on your drawing paper than are placed on the photo, your drawing size will be increased. Smaller squares will produce a smaller drawing. For accuracy be sure your boxes are perfect squares.

Wood Duck

I was amazed when I got this photo back from the processor. It looks almost unreal, due to the soft color of the water, the distinct patterns of the water ripples and the extreme coloration of the duck itself. To me, it was the perfect candidate for drawing. I chose to draw this on a French Blue no. 972 piece of mat board because of the soft color of the background.

This sketch will be used later for a Prismacolor drawing. This project is very colorful and vibrant, and Prism-acolor is the only pencil capable of creating such vivid, smooth coloration. The example can be seen on page 60.

This little guy has many detailed patterns to draw, so be sure to let the grid be your guide. Capture as much information as possible in the drawing; it will make your job of adding the color much easier.

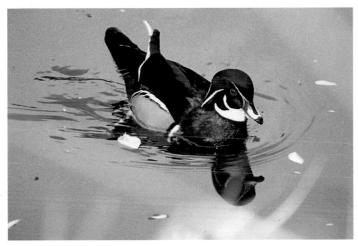
Photo reference

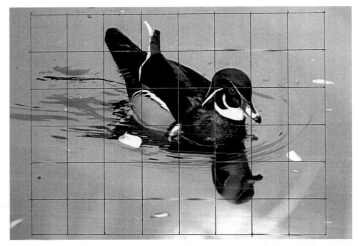
A copy of the photograph with a 1-inch (2cm) graph applied.

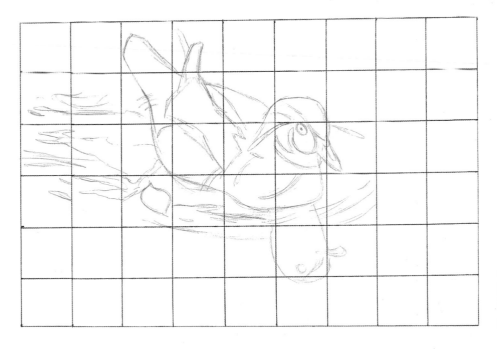

An accurate line drawing of the photo that has been drawn within a grid. The same size boxes were used. This will be used for a project on page 60.

White Hawk

This is a beautiful example of a white hawk. I love the way the light and shadows dance across its body. Its smooth, delicate textures and subtle color make it a wonderful example for drawing.

This will be used later for a project using Prismacolor pencils on suede board. I chose this approach because the soft texture of the paper will be useful in creating the same softness seen on the bird.

This suede paper, however, cannot be graphed on. Use a thin piece of typing paper to grid this line drawing. I will show you how to transfer it to the suede board later. When making your line drawing, look at all of the feather shapes and how they overlap one another. This information will be helpful when you apply the color. You can find this project on page 66.

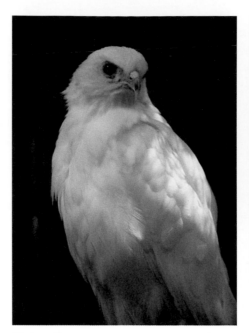
Photo reference.

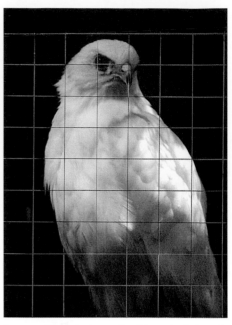
A copy of the photograph with a 1-inch (2cm) graph applied.

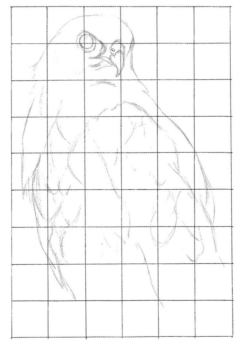
An accurate line drawing of the photo that has been drawn within a grid. The same size boxes were used. This will be used for a project on page 66.

Seagull

This photo will be used for a project using the Studio pencils by Derwent. The smooth coloration of the seagull will be captured perfectly by a blended technique.

This line drawing should be placed on a sheet of Cotman watercolor paper. The fibrous texture of the paper will enhance the blended technique, making it look very realistic. This project can be found on page 72.

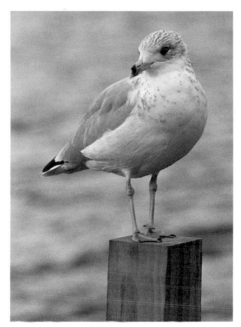

Photo reference.

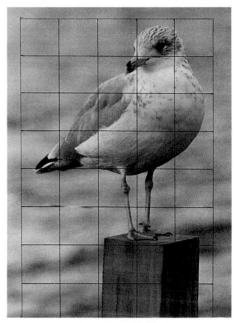

A copy of the photograph with a 1-inch (2cm) graph applied.

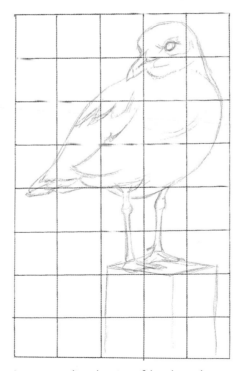

An accurate line drawing of the photo that has been drawn within a grid. The same size boxes were used. This will be used for a project on page 72.

Swan

This photograph of a swan also has distinct shapes within the water ripples. The mirror reflections add a lot of interest to the picture. The graceful shape of the swan combined with those patterns makes for a good drawing. Later in the book, on page 76, I will show you how to turn this into a painting using Watercolor pencils.

I have used the same Cotman watercolor paper as I did for the Seagull on page 33. Again, be sure your graph lines have been applied lightly. Heavy erasing will damage the paper's surface, causing the water to "misbehave" later on. Be as accurate as possible in your shapes. Look how pretty the water reflections are.

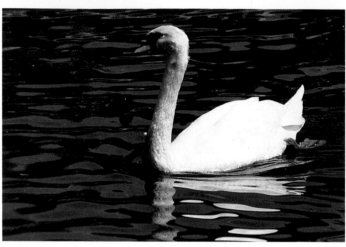

Photo reference.

A copy of the photograph with a 1-inch (2cm) graph applied.

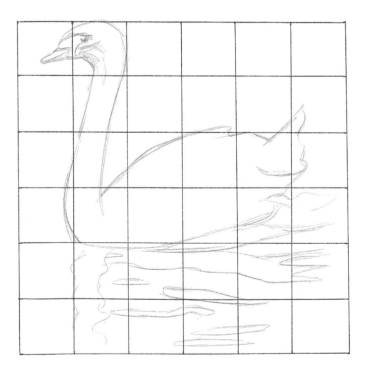

An accurate line drawing of the photo that has been drawn within a grid. The same size boxes were used. This will be used for a project on page 76.

Beaks, Feet & Feathers

Before we begin the detailed drawings of entire birds, we need to understand some of the important features. When drawing a particular species, it is essential to capture the specific details of that particular bird. Each species has unique characteristics seen only with them, and capturing that type of detail will make your artwork look more authentic.

One of the most recognizable features of many birds is the beak or bill. Beaks range in size, shape and color. Some seem highly useful and functional, while others seem merely decorative.

The beak is used for many things, such as eating, catching prey, building nests and self-defense. Here are a variety of bills and beaks. Study each one for its unique qualities. All of these drawings have been done with Prismacolor pencils due to the smooth, shiny surfaces of the beaks and the brilliant colors.

While studying the various beaks, also look at the eyes. They, too, are designed according to the bird's particular needs. Birds of prey, such as eagles, hawks and owls, have very large eyes. They can see a moving target far off in the distance. Since an owl flies at night, its huge eyes allow light in, enabling it to navigate in the dark.

All of these features make each bird different and gives you the artist, a wide variety of subjects to draw.

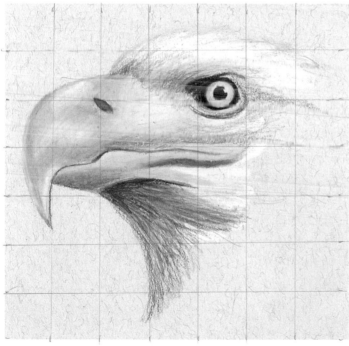

BALD EAGLE
This large, hooked beak is used for killing and shredding its prey. The large eye allows the eagle to see far off in the distance.

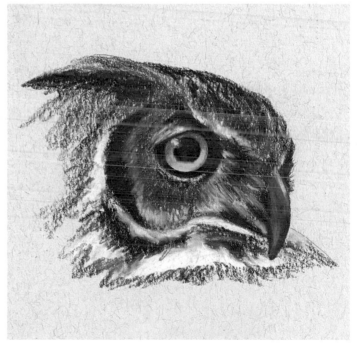

OWL
The owl has a smaller version of the hooked beak. It, too, is a meat eater that uses its beak to shred.

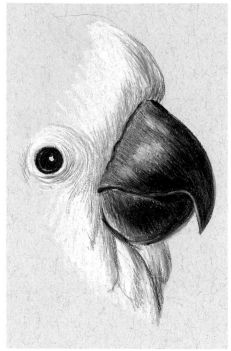

COCKATOO
This is what is called a "cracker" bill. It is designed for cracking open seeds and nuts.

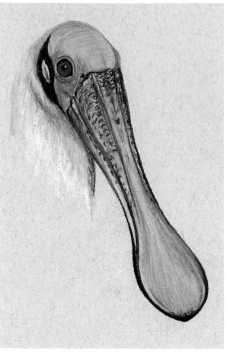

SPOONBILL
This handy tool is designed for scooping things up from the bottoms of streams and rivers, and sweeping through the water looking for food.

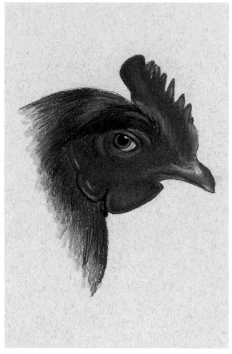

CHICKEN
This beak is used for pecking the dirt and cracking seeds.

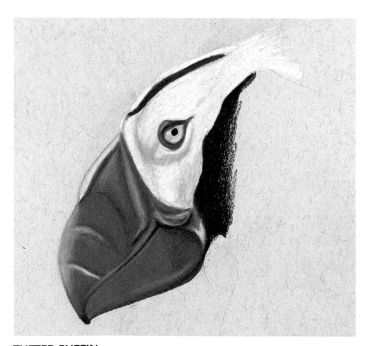

TUFTED PUFFIN
This colorful beak is quite useful for catching fish underwater.

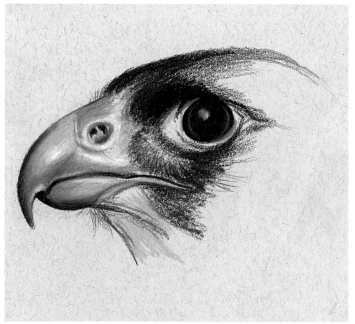

RED-TAILED HAWK
This has a similar shape and function as the eagle's beak. The hawk and the eagle are both considered to be birds of prey.

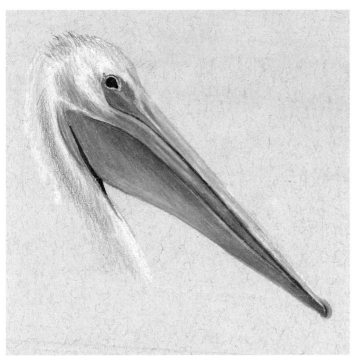

PELICAN
This bill is used as a huge net to scoop up fish from the water.

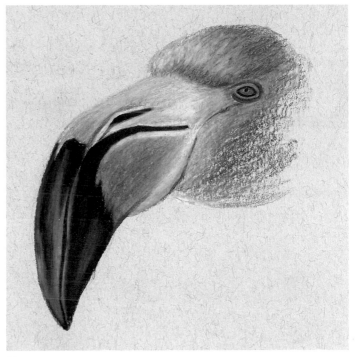

FLAMINGO
The flamingo has a very decorative beak, which also serves as a tool for catching fish.

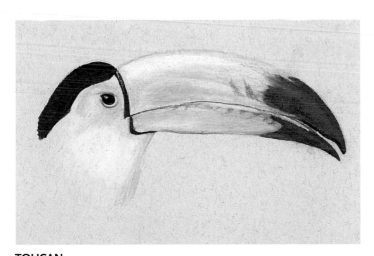

TOUCAN
This brightly colored bill is more for decoration and courting mates than for eating purposes. A toucan is a fruit eater.

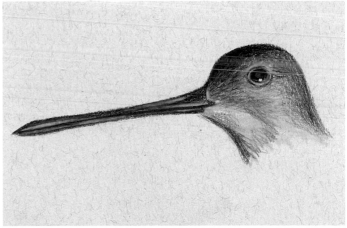

SNIPE
This beak is designed to poke and probe through the sand looking for tasty morsels.

Feet

Another important feature that varies from bird to bird is the feet. Just like the beaks and eyes, the feet are adapted to aid with certain jobs and behaviors. Study the examples here, and you can see how similar, yet how different each type of foot appears. Refer back to the photographs of the rhea and the flamingo on page 27. The rhea has much thicker legs and has larger feet designed for running. The flamingo has slender legs and webbed feet designed for walking and swimming in water.

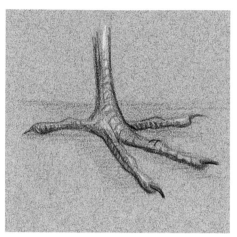

This is a foot used for perching. This is the foot of a robin.

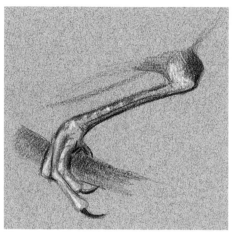

The robin's long hind toe gives the bird the ability to tightly grasp a branch.

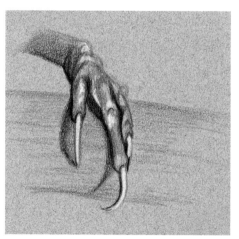

Often the fourth toe is not seen when holding a branch.

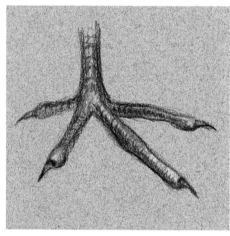

This foot is designed for scratching. The back toe is much shorter than on a perching foot, and the three toes in front resemble a rake. You would see feet like this on a chicken or pheasant.

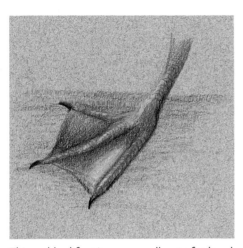

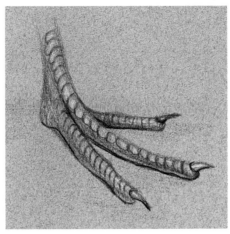

NOTE—
The legs of birds will vary in length. Birds of the air and birds that climb have shorter legs. Many ducks have short legs, for swimming. Birds that run fast or wade through water have the longest legs.

This webbed foot is seen on all waterfowl and provides a paddle to help the bird propel through the water.

This running foot has three toes instead of four. Emus, rheas and killdeer all have these three-toed feet. An ostrich is the only bird with two toes.

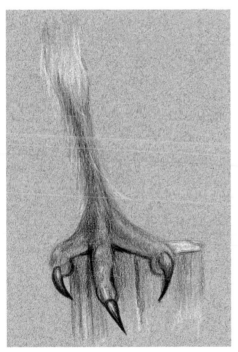

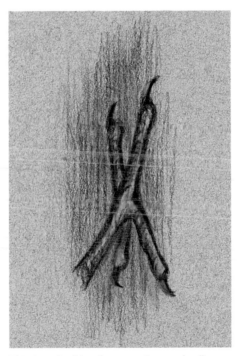

This is a grasping foot seen on large birds of prey. It gives them the ability to fly down and snatch up their victims.

This is a climbing foot seen in tree dwellers, such as swifts and woodpeckers.

Feathers

Naturally, when you think of a bird, you think of feathers. They are what make a bird fly and what keep it warm or cool. They help attract attention or camouflage a bird completely. Feathers can be long or short, hard or soft. They can be riddled with patterns and markings or a solid color.

When I see a large feather, such as the top one shown here, I always think of an ink well. Long ago, large feather quills were used as writing utensils because the long shaft of the feather or quill is hollow. By placing a small opening in the side of the quill and piercing a tiny hole in the end, the quill could be dipped in ink and it would flow as in a regular fountain pen. It is the hollow quill that makes the feather lightweight and suitable for flying.

A feather has important details that you must understand before you can draw one convincingly. To me, feathers resemble the formation of a leaf or fern. The web of the feather comes out from the center quill, producing a flat vane on either side. The vane is made up of hundreds of parallel branches. Things called hooklets, or barbs, hold this web, or vane, together. This is what makes the feathers resistant to the air, keeping the bird in flight. Without the web, air would pass through the feather, like it would with fur or hair. Flying would then be impossible.

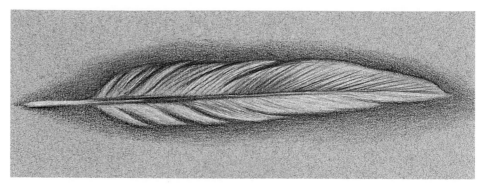

QUILL FEATHER

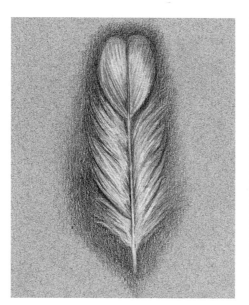

CONTOUR FEATHERS
Found on the body of the bird, contour feathers hug the body and act as a coat for protection and insulation. The fuzzy area at the base of the feather is called the down and is found beneath the outer feathers. On waterfowl, such as ducks and geese, down is what keeps them warm. Feathers are very water-resistant. Watch a duck in the water, and you will see water roll right off it.

Feathers overlap on a bird, much like shingles on a roof.

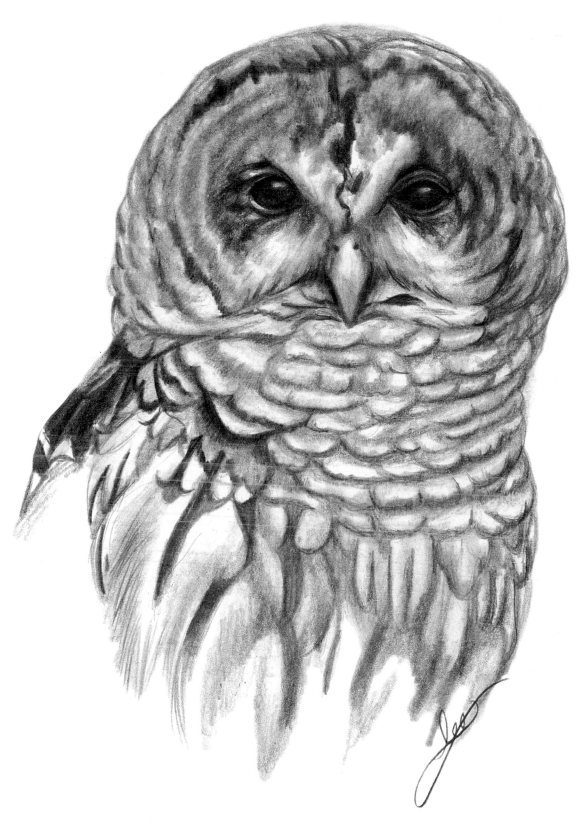

The overlapping feathers can be seen clearly in this drawing of an owl.

Foreshortening

Sometimes when observing birds, you'll notice that the length of the tail appears distorted. When the feathers are projecting toward us the angle causes the length of the tail to be visually shortened. This is called foreshortening. Look at the three sparrows shown here, and notice how the varying positions create different amounts of foreshortening.

These birds all have similar tails. They just seem different due to the positionings. Remember to look for foreshortening whenever you draw something that is long in shape.

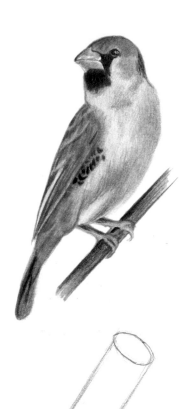

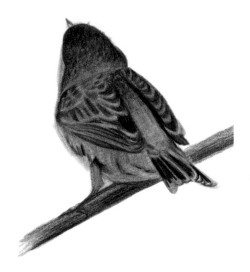

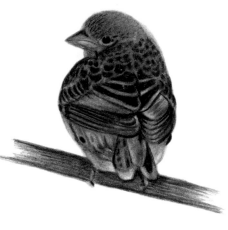

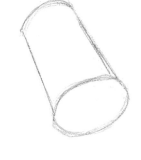

Notice how the soft feathers of the chest blend together, and the individual feathers cannot be seen. From this view, you can see the entire length of the tail. Compare it to the cylinder shape shown above.

This view shows three distinct rows of feathers. The long ones at the tips of the wings are called primaries, and are flight feathers. The next row, closer to the body, are called secondaries. The smaller feathers that cover the base of the larger ones are called coverts. This angled view distorts the length of the tail, giving it a shorter appearance. The cylinder above shows the tail position and perspective.

This back view completely alters the perspective. The length of the tail feathers is completely lost. See the cylinder above for the position.

Feathers in Flight

The most important function of feathers is to aid in the flying process. Look at the outstretched wings of this parrot in flight. You can clearly see the three layers of wing feathers as I described before. Look at how the feathers overlap and splay out at the tips. These wings are good for short distances and flying from tree to tree.

The wings of seagulls look totally different. Their feathers are closer together, and their wings are much longer. They are designed for gliding and soaring along the air currents. They are also used for diving.

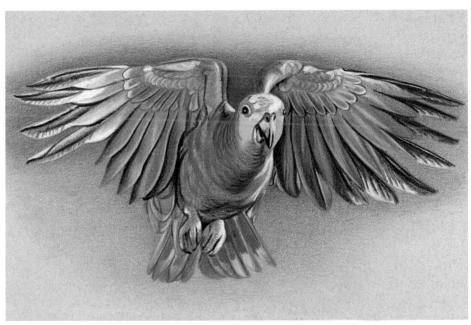

PARROT IN FLIGHT
Verithin pencils on Moss Green Renewal paper
9" x 12" (23cm × 30cm)

COLORS USED

Parrot: True Green, Apple Green, Dark Green, Indigo Blue, True Blue, Aquamarine, Canary Yellow, Poppy Red, Black and White.
Background: Indigo Blue and Light Blue.

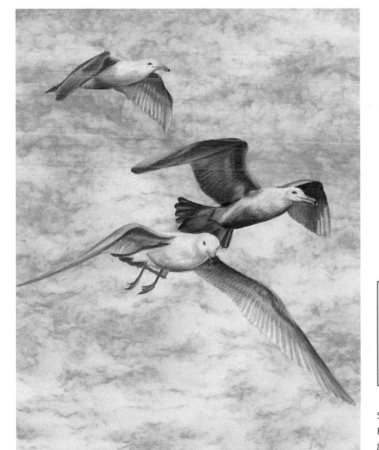

COLORS USED

Dark Brown, Light Umber, Cool Gray 50%, Sienna Brown, Yellow Ochre, Black and White.

SEAGULLS IN FLIGHT
Prismacolor pencils on Gray Marble paper
8½" x 11" (22cm x 28cm)

Study Actual Bird Wings

By looking at the wings from actual birds, you can see and study the anatomy much better. Take a look at the wings shown at right from a great horned owl, and notice their beautiful markings. These two examples were taken from unfortunate birds that were hurt and killed in the wild and are now being used for educational purposes. Look closely and you will see the three layers of feathers and the quills.

In order for a bird to fly, it needs more than just feathers. The body structure of a bird is very lightweight, but it is very strong. Look at the wingspans of the vulture and bald eagle shown on these two pages. Under their feathers are strong muscles that pull the wings up and down. Compared to a human, the bird has much more powerful chest muscles for its size.

Look at the differences in the feathers of all these birds. Each has a different texture and appearance.

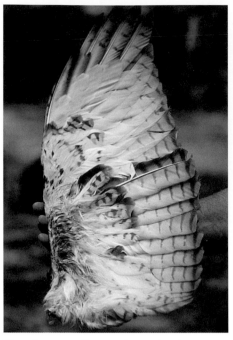
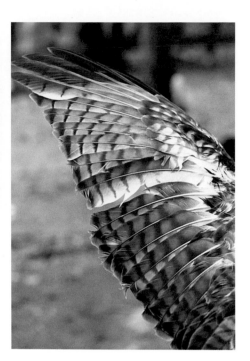

The wingspan of a great horned owl.

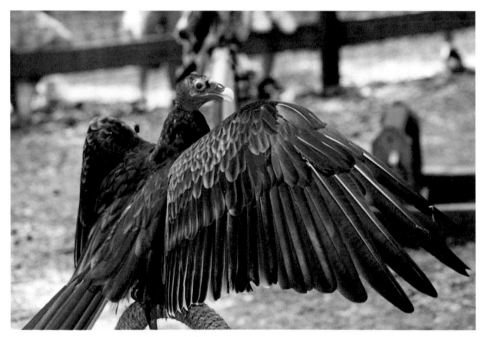

The wingspan of a turkey vulture.

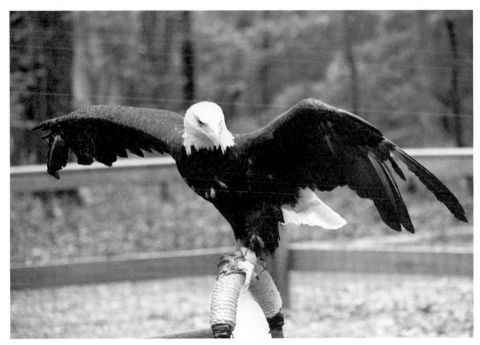

The wingspan of a bald eagle.

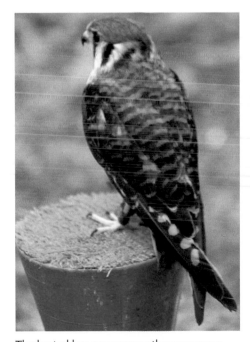

The kestrel has a very smooth appearance and has beautiful markings. The closed wings cover the body of the bird. Look at how the wing tips cross one another at the end. This helps keep the bird balanced while standing on the flat surface.

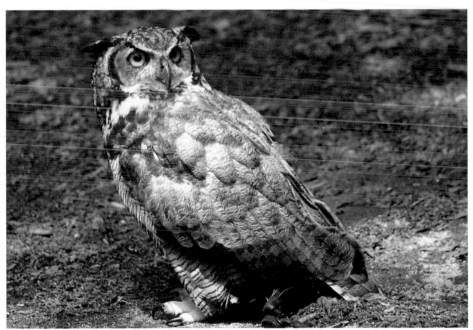

The great horned owl also has beautiful markings. It has a thick feather layer, which creates a fuller, more textured appearance. You can clearly see the overlapping of the feathers, which creates the shingled look.

Verithin Pencils

When I introduce students to colored pencil, I like to start them with the Verithin brand. Verithins are good pencils to use when learning to experiment with color. They have dry, thin leads. They can be sharpened to a fine point, which is their most valuable characteristic. It is important to have a quality pencil sharpener for these, as with any art pencil. I recommend an electric or battery-operated one.

When drawing with colored pencil, the paper that you use is as important as the pencils you are drawing with. A good example can be seen in this drawing of a red-tailed hawk. I selected this marbleized paper to represent a skylike background. The brown tones became part of the drawing and helped create the color of the bird, giving it an interesting effect. Had I drawn this bird on a white background, the effect would not have been nearly as striking.

VALUE SCALE
Examine this value scale. The colors layer without mixing together. The surface of the paper shows through, creating a somewhat grainy effect. This is a wax-based pencil, but it does not have enough wax in it to build up and completely cover the paper. That is why I like this pencil. The layered approach looks very artistic to me.

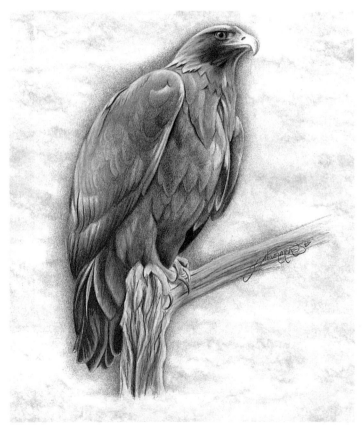

RED-TAILED
HAWK
Verithin and
Prismacolor pencils
on Brown Marble
paper
19" x 24" (48cm x
61cm)

COLORS USED

Dark Brown, Sienna Brown, Terra Cotta, Golden Brown, Yellow Ochre, Aquamarine and Black. White Prismacolor was used for the sheen on the shoulders, beak and the catchlight in the eye and the limb.

This drawing of a red-tailed hawk was done with a light, layered approach. Notice how the graininess of the pencil has become part of the texture of the bird. This method captures the subtleties of the textures, without looking harsh. To make the highlight areas look vivid, I used a White Prismacolor pencil. It is very important to keep a sharp point on your pencil at all times with this technique. Because of the light application of pencil, light areas can be lifted and softened with a kneadable or typewriter eraser.

Let's examine some other drawings done with Verithin pencils. This study of a cardinal's head shows the beautiful layering effect achieved with these pencils. I chose a speckled, recycled paper called Artagain by Strathmore. The speckled surface makes the layered application of pencil more noticeable. Look at how all of the colors layer on top of one another. They don't build up and blend together, but remain independent. Each color can still be seen through the others. The line quality of the pencil shows through and becomes part of the texture.

For the beak, I switched to Prismacolor pencils in order to capture its smooth, shiny surface. If done with the Verithin pencils, the texture would have looked too porous to be realistic. The same is true for the eye. I will often use a Prismacolor or Negro pencil to achieve the deep black necessary for the pupil.

These little hummingbirds were also done with Verithin pencils. I was able to produce a crisp line with them, which was necessary for capturing the fine lines seen within the wings. Verithin pencils are also good for creating very subtle color changes, as you can see here in the hummingbirds' bodies and heads.

This head study of a thrush shows the delicate layering of colors necessary for creating the bird's texture. Its feathers have the same grainy look that this pencil produces. Look closely and you will see one color layered on top of another. The sharp point of the pencil creates delicate lines, which replicate the texture of the bird.

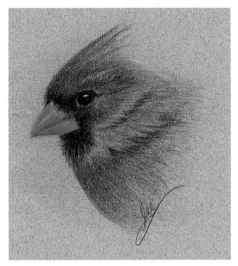

CARDINAL
Verithin pencils on Moonstone Artagain paper
8" x 10" (20cm x 25cm)

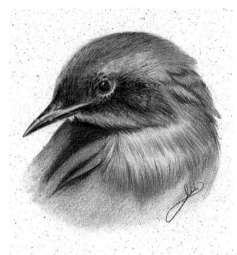

THRUSH
Verithin pencils on Banana Fiber paper
9" x 12" (23cm x 30cm)

COLORS USED

Body: Poppy Red, Yellow Ochre, Dark Umber and Black.
Eye: no. 1 Negro.
Beak: Salmon Pink and White Prismacolor.

COLORS USED

Dark Brown, Golden Brown, Terra Cotta, Canary Yellow, no. 1 Negro and White Prismacolor pencil.

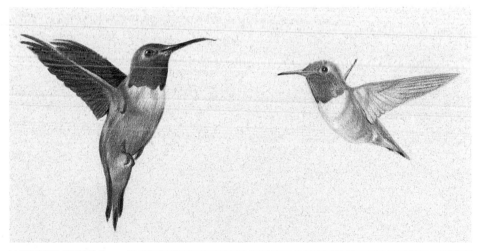

HUMMINGBIRDS
Verithin pencils on Beachsand Artagain paper
12" x 18" (30 cm x 46cm)

COLORS USED

Bird no. 1: Dark Brown, Golden Yellow, Poppy Red, Black and White.
Bird no. 2: Golden Yellow, Poppy Red, Canary Yellow, Aquamarine, Olive Green, Black and White.

Using Colored Papers

I chose a recycled paper for this drawing. It is called Banana Fiber. It is much thinner than the Artagain but has a wonderful, natural look to it. It gives the drawing of the ducks an earthy, natural feel. The brown speckles blend into the drawing and become a part of it.

One of the things I liked the most about this drawing was the use of shadow below the larger duck. By emphasizing the shadow, the bright sunlight effect on the bird's neck becomes more obvious. By using a darker background, the reflected light can be seen down the front of the larger duck. Look for the egg shapes here.

This tricolored heron was a fun one to draw. Since I wanted to accentuate the unusual coloration of the bird, I chose a mat board called Cameo Rose no. 973. Not only does the color of the mat board add interest, it becomes part of the color of the bird. The Verithin technique allows the board color to come through. Because the board is somewhat dark, I was able to use White for the highlight areas. White gives it a more dimensional feel. I used Prismacolor pencils for the beak and legs to make the yellow coloration more vivid. I also used a light application of Cloud Blue Prismacolor in the background to suggest a slight illusion of the sky.

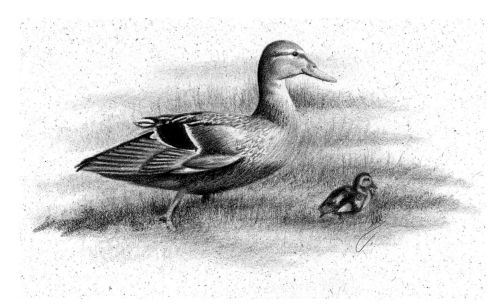

MAMA AND BABY GOING FOR A WALK
Verithin pencils on Banana Fiber paper
9" x 12" (23cm x 30cm)

COLORS USED

Ducks: Dark Brown, Golden Brown, and no. 1 Negro for the black areas.
Background: Dark Green, Golden Brown and Olive Green.

COLORS USED

Verithin: Light Blue, Mulberry, Golden Yellow and Black.
Prismacolor: Canary Yellow, Cool Gray 50%, Yellow Ochre, Cloud Blue and White.

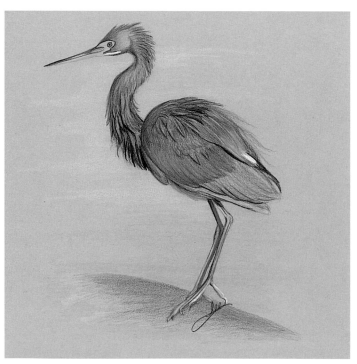

TRICOLORED HERON
Verithin and Prismacolor pencils on no. 973 Cameo Rose mat board
9" x 12" (23cm x 30cm)

Using Complementary Colors

The use of color is very important in drawing. That is why I included the color wheel in chapter four as a reference. The drawings below show how you can use complementary colors to enhance your work.

The red crossbill was drawn using opposite colors on the color wheel. Since the bird had such a pretty color mixture of orange and yellow, I used violet and blue in the background to make it stand out. I then repeated those colors by reflecting some of them into the beak, wings and tail. It also can be seen in the highlight area of the wood.

Although Verithin pencils have a delicate application, they can still be used for bold color statements. Examine this drawing of a peach breasted conure, and you can see what I mean. I started with a mat board called India no. 912. It has a golden coloration that shows through in this drawing. All of the colors of this bird overlap, creating very subtle color changes. To enhance the greenish hues of the bird, I used shades of red in the background. (The opposite, or complement, of green is red.)

When doing an even layering over a large area, always keep the pencil sharp. If the pencil point becomes dull, its line width broadens and the application of tone looks like crayon.

PEACH BREASTED CONURE
Verithin pencils on no. 912 India mat board
8" x 10" (20cm x 25cm)

RED CROSSBILL
Verithin pencils on Chamois Renewal paper
8" x 10" (20cm x 25cm)

COLORS USED

Pumpkin Orange, Dark Brown, Golden Brown, Dahlia Purple, Violet and Black.

COLORS USED

Bird: Apple Green, Turquoise, Canary Yellow, Dark Brown, Poppy Red and Black.
Branch: Dark Brown, Golden Brown, Black and White.
Background: Terra Cotta and Black.
Beak, eye and feet: White, Black and Clay Rose Prismacolor.

Drawing a Red-Tailed Hawk Step-by-Step

Now you are ready to start your own project. Follow the step-by-step directions carefully. Using the line drawing from page 29, let's draw the red-tailed hawk together.

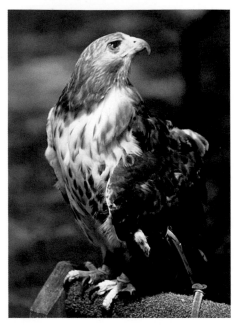

Carefully examine the original photograph for the details of the hawk. Make sure that you have captured all of the shapes accurately. Refresh your memory by referring back to the graph exercise on page 29.

1 Once you are sure of the accuracy, you can remove your graph lines with the kneaded eraser and begin to add the tones. I always start my renderings with the eyes. The eyes hold all of the life and personality of the bird. By doing them first, I get the feeling of a living creature right away. I drew these eyes using Golden Brown and Terra Cotta, along with black. I first filled the colored areas of the eye with the Golden Brown and then added the Terra Cotta to the edge. The lightest area of the iris is the tone of the paper showing through. To make the pupil of the eye as deep as possible, I used a no. 1 Negro pencil.

With the same black pencil, I then began to add some of the dark shadow areas around the eye, under the beak and to the body of the bird. When your drawing looks like mine, you can proceed to the next step.

2 With the same Golden Brown we used for the color of the eye, begin a light application of tone to the head and chest. Go over the black you have already applied.

COLORS USED

Golden Brown, Terra Cotta, Cool Gray 70%, Dark Brown, Light Blue and no. 1 Negro.

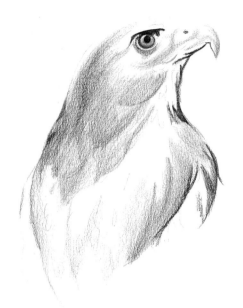

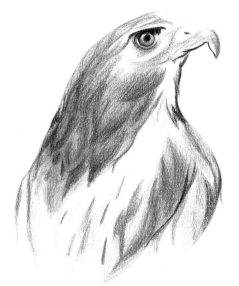

4 With Dark Brown, go over the Terra Cotta. Continue building the shapes of the feathers. Can you see how dimensional it is now beginning to look? Also, can you see how the three colors we layered can all still be seen? Keep adding the Dark Brown until your drawing looks like mine. With more Terra Cotta, add the patterns on the chest.

3 With Terra Cotta, go lightly over the Golden Brown. This is the stage where you develop the shapes of the contour feathers. With Cool Gray 70%, lightly color in the shadows of the beak.

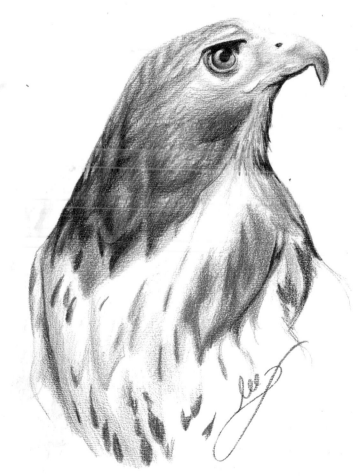

5 Now for the final touches. Use the Cool Gray 70% to create the shadow on the lower portion of the chest. This makes the bird look rounded. Then, with Light Blue, add a hint of color to the head, beak and throat. This gives the illusion of the sky color reflecting off of the hawk. Beautiful!

Drawing an American Kestrel Step-by-Step

Since Verithin pencils are one of my favorites for drawing birds, I've included another project for you. This one will give you practice drawing an entire bird. Let's go back to the line drawing from page 30 and draw the American kestrel together.

<div>
COLORS USED

Golden Brown, Terra Cotta, Light Blue, Dark Brown, Indigo Blue, True Green, Dark Green, Black and no. 1 Negro.
</div>

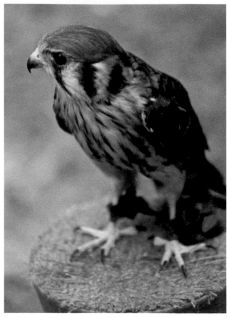

Review the original photo, and check your line drawing for accuracy. Once you are sure you have captured all of the details, you can remove your graph with the kneaded eraser. This little guy has a lot more patterns and details to capture, so take your time.

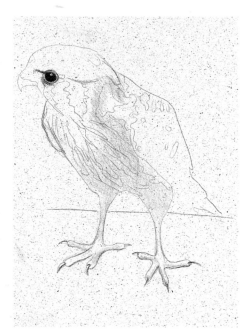

1 Again, I started with the eye to capture the life of the bird. For this I used my no. 1 Negro pencil. The highlight in the eye is the paper showing through. This bird has no other color in its eye.

With Golden Brown, lightly apply some color to the body of the bird. It is the same approach we used for the drawing of the red-tailed hawk. This bird has a white area on the chest; so don't fill it in all the way. Leave some paper exposed. Take some of the same color down into the legs and feet.

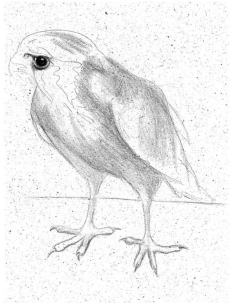

2 With Terra Cotta, go over the Golden Brown to deepen the coloration. You will still see the Golden Brown underneath. Apply some Terra Cotta to the wing area to act as a base color.

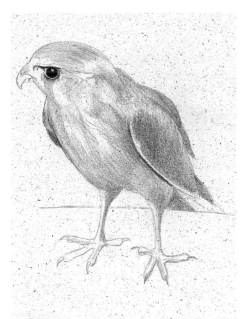

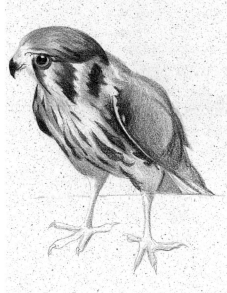

4 Build up the blue color of the head and wing by adding Indigo Blue on top of the Light Blue. Streak a little of the Indigo Blue into the chest area also. With the no. 1 Negro pencil, begin adding in the dark patterns of the bird. Be sure you accurately place them. These markings are important to the species.

3 With Light Blue, add some color to the top of the head, base of the beak, throat area and wing. With Dark Brown, add some shadows to the chest, wing, legs and feet. The bird is now taking on some dimension.

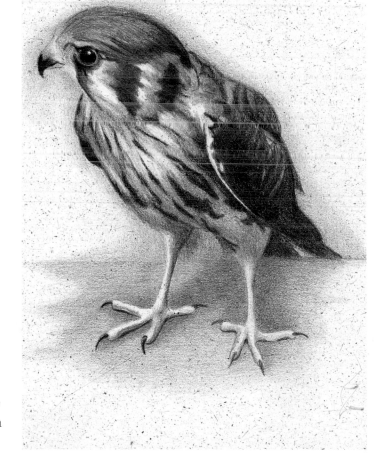

5 To finish the drawing, add a light touch of Dark Brown into the background directly behind the bird. Add some green to the areas below with a combination of True Green and Dark Green. The shadow area below the bird was created with the Black Verithin pencil.

Prismacolor Pencils

While Verithin pencils offer a subtle look, sometimes you may want to create a brighter, bolder statement in your work. Prismacolor pencils are designed for just that. Study these value scales, and you can see how different the two pencils look.

Look at this beautiful drawing my student drew. It was drawn from a picture she took while on a trip out of the country. Look at the vivid colors and details. She captured it perfectly. It looks almost like a photograph. It is this heavy buildup of color and the ability to capture sharp detail such as this that make Prismacolors so unique.

When I look at the photo references I have, each one may need to be drawn differently. To draw the toucan on the next page, Prismacolor was my only choice—no other pencil would capture such vibrant colors. Look at how smooth and shiny the beak appears. The waxy formulation of these pencils is perfect for depicting this type of surface. They are also good for creating interesting backgrounds. This one was created by heavily applying a number of colors in a horizontal fashion. This technique of building up color like this is called burnishing. It is the process of blending one color into another using the lighter color to soften them.

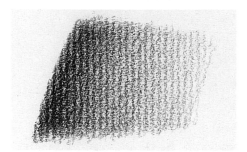

A value scale drawn in Verithin pencils.

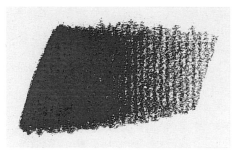

A value scale drawn in Prismacolor pencils.

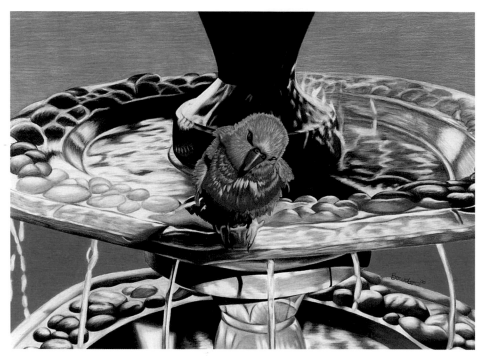

ON THE FOUNTAIN
Prismacolor pencils on no. 1008 Ivory mat board
16" x 20" (41cm x 51cm)
Artist: Abby Bowden

Because of the large amount of wax in these pencils, you may notice a haze forming on your work. The wax rises to the surface causing the milky look. Do not be alarmed. You are doing nothing wrong. Lightly rubbing it with your finger or a tissue will make it disappear temporarily. However, when you are finished with your work, you must spray it with a fixative to eliminate the haze permanently. You can choose a matte spray, which will not be noticeable, or a gloss varnish which will make your work look shiny. I use both, depending on the subject and how I want it to look.

This little puffin below has lovely white areas, which this pencil captured beautifully. I chose Artagain paper in Storm Blue for this drawing, as it offered just the right amount of contrast.

Prismacolor is also a good pencil for building up colors and depicting white and black area. I like to tell my students, "Black isn't black, and white isn't white!" Both of them require the addition of other colors to make them appear dimensional. This is true for any color or surface. Anything that is filled in with one continual tone will appear flat. Look at the white area of this bird. Can you see all of the different colors reflecting up into it? I particularly like the way the colors of the feet are bouncing up onto its chest Look at the areas of black. Can you see the subtle highlight areas? These lighter areas make the puffin look rounded.

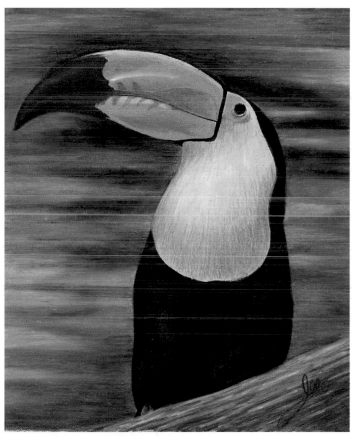

TOUCAN
Prismacolor pencils on no. 1008 Ivory mat board
8" x 10" (20cm x 25cm)

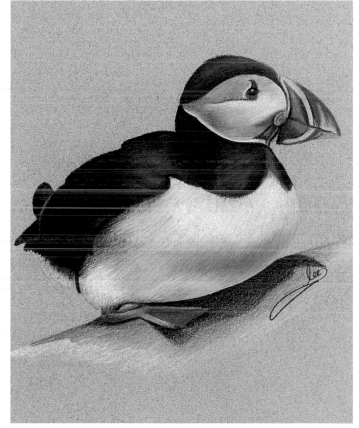

PUFFIN
Prismacolor pencils on Storm Blue Artagain paper
9" x 12" (23cm x 30cm)

Prismacolor Examples

The following examples were all done with Prismacolor pencils, utilizing different techniques, papers and approaches. Look at the different ways the pencil was used to create the special look of the specific bird.

This quail was harder to draw than it looks. The feather patterns on the chest and neck were difficult to capture. However, it is this type of detail that is necessary for realism. Notice how a reflection of color can be seen on top of the white. Because

of the very smooth surface of the quail, I used a heavy, burnished approach.

This cockatiel was also created with a heavy, burnished approach. The Green Marble paper added an interesting look. Since this particular paper was from a stationary store, it has a different surface than the marble art paper. Look closely and you can see it has a linen look to it, which showed through into the drawing. I further enhanced this textured look

by using a craft knife and scraping small details into the feathers and tree limb. To help the bird stand out against the background, I deepened the darker areas of the marble paper with a Dark Green Verithin pencil.

I created this great horned owl by combining both Prismacolor and Verithin pencils. The even layering of the background contrasts against the heavy application on the bird. You can see how well the two types of pencils work together.

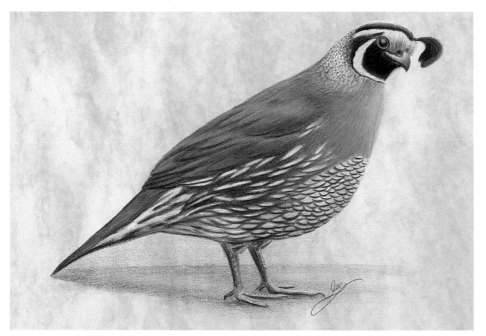

QUAIL
Prismacolor pencils on Brown Marble paper
9" x 12" (23cm x 30cm)

> **NOTE—**
> To contrast against the heavy technique used to draw the bird, I lightened my touch and drew in the ground with a layered approach.

> **COLORS USED**
>
> Cerulean Blue, Parma Violet, Grayed Lavender, French Gray 90%, Deco Yellow, Orange, Dahlia Purple, Black and White.

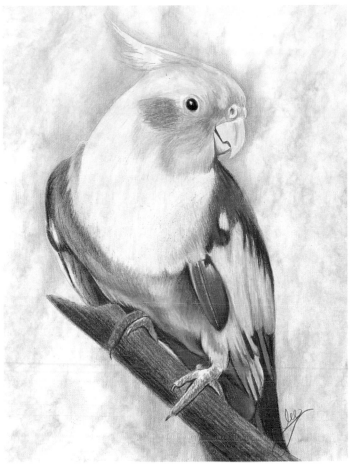

COCKATIEL
Prismacolor pencils on Green Marble paper
9" x 12" (23cm x 30cm)

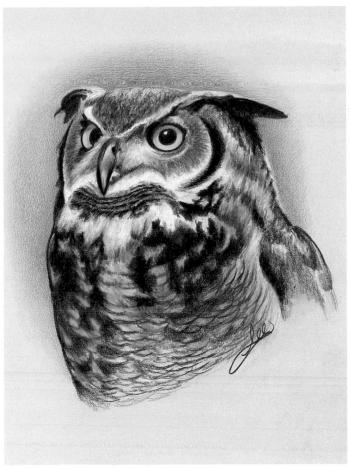

GREAT HORNED OWL
Prismacolor and Verithin pencils on no. 903 Soft Green mat board
12" x 16" (30cm x 41cm)

COLORS USED

Bird: Deco Yellow, Mahogany Red, Dark Brown, Poppy Red, Yellow Ochre, Terra Cotta, Black and White.
Branch: Terra Cotta and Dark Brown.

NOTE—
To enhance the depth of tone in the marble of the paper, I deepened certain areas with a Dark Green Verithin pencil. You can see it around the face.

COLORS USED

Bird: Dark Brown, Sienna Brown, Yellow Ochre, Terra Cotta, Canary Yellow, Black and White.
Background: Turquoise, Grass Green and Cool Gray 50% Verithin. I used the Turquoise pencil to reflect the blue tones into the beak and face.

NOTE—
For the texture and pattern of these feathers, I used a looser approach by leaning my pencil more on the side.

Creating an Entire Scene

Sometimes I like to create an entire scene along with the bird, for a total composition. These two examples show what can be created.

This drawing of a cardinal depicts a winter mood, by contrasting the bare, white limbs against the black background. The bright red of the cardinal stands out against the neutral tones of black and white. Look closely at the texture of the bird, and you can see where once again, I have used the craft knife to scrape in small details and textures.

The white color of this egret stands out against its much brighter surroundings. By including the total scene along with your bird illustration, you create more than just what the bird looks like; you can tell the viewer more about how it lives and what it does.

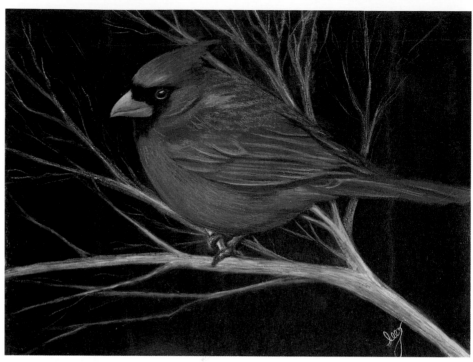

CARDINAL IN THE WINTER
Prismacolor pencils on no. 1008 Ivory mat board
8" x 10" (20cm x 25cm)

COLORS USED

Poppy Red, Tuscan Red, Scarlet Lake, Peach, Black and White.

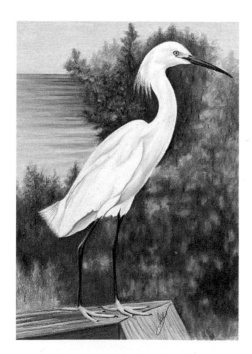

COLORS USED

Bird: White, Clay Rose, Grayed Lavender, Cloud Blue, Dark Brown, Canary Yellow, Golden Yellow, Orange, Sand and Black.
Foliage: Spring Green, Apple Green, Olive Green, Chartreuse, Limepeel, Dark Brown, Deco Yellow, Yellow Chartreuse, Black and White.
Background: Cloud Blue, Lavender, True Blue, Parma Violet and White.
Wood deck: Dark Brown, Sienna Brown, Black and White.

EGRET
Prismacolor pencils on no. 3297
Arctic White mat board
12" x 16" (30cm x 41cm)

NOTE—
To make the cardinal and the white, wintery limbs stand out, I filled in the background with Black. I then sprayed the entire drawing with a heavy application of gloss varnish to make it look shiny.

Working on Black Paper

One of the most interesting characteristics of Prismacolor is that it is opaque and brilliant enough to use on black paper. The next two examples show how striking this effect can be.

This swan is one of my favorite drawings. The black swan was at our local petting zoo and was quietly resting in the cool grass. I think he is just beautiful with the greens and blues reflecting off of his sunlit feathers. Look how vibrant the orange color of his beak appears in contrast to the rest of the drawing. A tint of orange is actually reflecting onto his beautiful neck. The bright greens of the grass show up nicely against the black paper.

My rooster looks very colorful against the black paper here. Can you see the difference in texture when compared to the swan? This was done on Raven Black mat board no. 989. It has a slight texture to it. You can also get it without the texture.

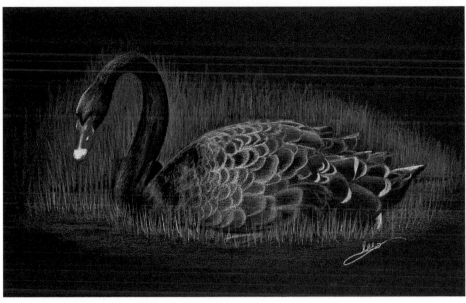

A RESTING BLACK SWAN
Prismacolor pencils on Black Artagain paper
12" x 18" (30cm x 46cm)

COLORS USED

Swan: Aquamarine, Grayed Lavender, Burnt Ochre, Peach, Cool Gray 50%, Black and White.
Grass: True Green, Apple Green, Aquamarine and White.
Ground: Burnt Ochre.

COLORS USED

Bird: Poppy Red, Peach, Tuscan Red, Terra Cotta, Sand, Carmine Red, Light Peach, Sienna Brown, Yellow Ochre, Cream, Black and White.
Background: Turquoise.
Ground: Terra Cotta, Cream, Peach, Deco Aqua and White.

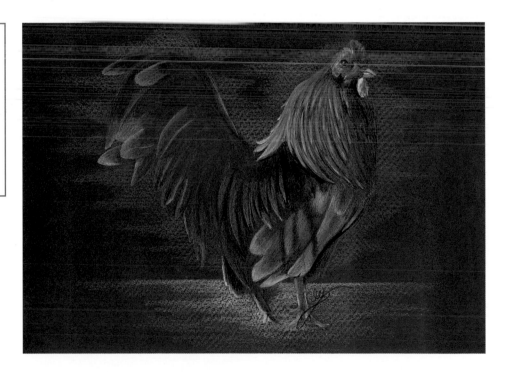

ROOSTER ON BLACK
Prismacolor pencils on no. 989
Raven Black mat board
12" x 16" (30cm x 41cm)

Drawing a Wood Duck Step-by-Step

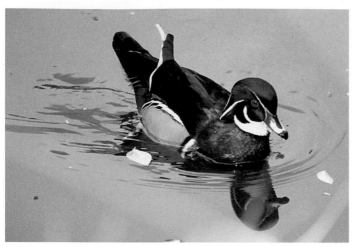

Using the line drawing from page 31, let's draw the wood duck. Study the original photograph carefully, and be sure your details are accurate.

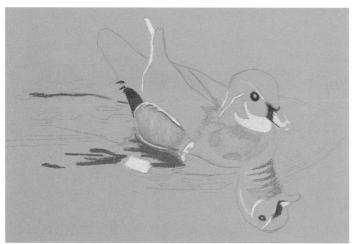

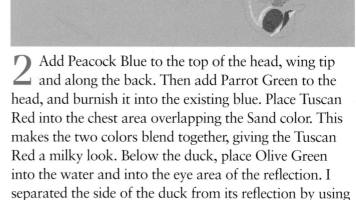

1 This wood duck has beautiful red eyes. I drew them in with Poppy Red; I also placed Poppy Red into the small area on the bill. Whenever you are drawing something that has a wide range of colors, it is better to begin placing the lighter colors first. Fill in the areas you see here with White first, then fill the next areas with Sand. The area under the tail is Terra Cotta. Terra Cotta was also used in the water reflection for the eye and bill. Place Bronze into the ripple shapes of the water.

2 Add Peacock Blue to the top of the head, wing tip and along the back. Then add Parrot Green to the head, and burnish it into the existing blue. Place Tuscan Red into the chest area overlapping the Sand color. This makes the two colors blend together, giving the Tuscan Red a milky look. Below the duck, place Olive Green into the water and into the eye area of the reflection. I separated the side of the duck from its reflection by using a line of White to represent the water edge.

NOTE—
Remember, reflections are never as bright as the main subject.

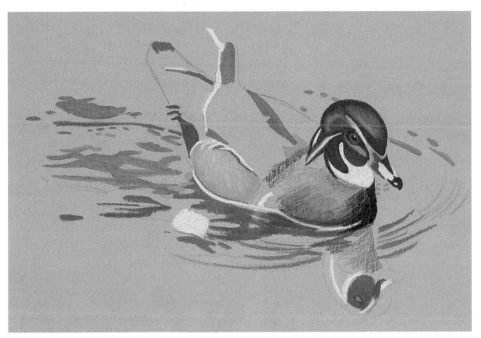

3 Now that the lighter colors have been put in place, it is time to fill in the Black in the head, the pupil of the eye and the dark shapes on the bill. Overlap the existing colors in the chest with Black. In the water below, I started to create the blue ripples with a combination of Periwinkle and Mediterranean Blue.

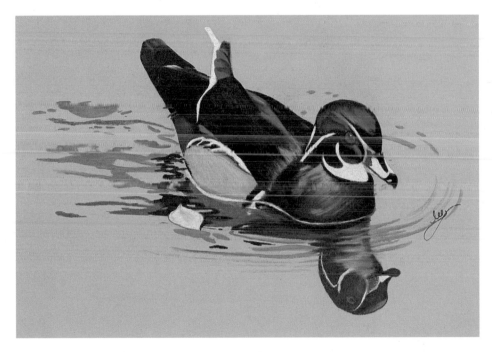

4 Adding the Black makes everything stand out and completes the drawing. You must blend the colors to make your drawing look real. If all of the colors were separate, it would look like a coloring book. Study how I burnished and blended the colors into one another. The colors of the head blend into the Black. By going back into the Black with the colors I used before—Parrot Green and Peacock Blue—the image softens. The Sand has been burnished into the Black on the chest and the back, making those colors seem softer also. Look at the head being reflected into the water. Can you see how I burnished the ripples with White to smear the edges, making them look more like reflections?

Prismacolor Pencils on Suede & Velour

We learned in the previous chapter how vivid and brilliant color can be when you use Prismacolor pencils. Their waxy composition allows colors to burnish and blend together, almost giving the look of an oil painting. But did you know that they could also produce a soft, pastel-like quality?

Study these two value scales. The one on the left is Prismacolor on regular mat board. The color is deep and rich. The second one has been drawn with the same pencil, but this time it has been applied to a piece of suede mat board. The difference is obvious.

There are two surfaces that I use to achieve this soft effect. One is suede mat board and the other is velour paper. Velour paper has actually been around for a long time. It was originally designed to be used with pastels. Suede mat board is made to be cut into mats for framing. I find that it has a beautiful surface for drawing, and I use it often for both Prismacolors and pastels.

Both suede board and velour paper have a fuzzy knap to them. The surface closely resembles a velvet fabric. The soft knap makes the pig-ment of the Prismacolor pencils fan out on its surface, diffusing the color into a smooth pastel appearance. Working on these surfaces is not a difficult technique to master. It requires a light touch and an even application of pencil, much like that of the Verithin technique. The result is a very smooth look, with no visible pencil lines.

Because these papers are so soft, burnishing is not suitable, except in very small areas, such as the pupil of the eye.

A value scale drawn with Prismacolor pencils on regular mat board. It has a deep, vivid appearance.

A value scale drawn with Prismacolor pencils on suede mat board. It has a soft, pastel-like appearance.

Suede Board & Velour Paper Compared

So what is the difference between suede board and velour paper? Look at these two birds and you will see. The parrot on the red background was drawn on a suede board called Garnet. You can see a swirled pattern ingrained in the surface, giving it a mottled look. Suede board is available in many colors, and all of them have this swirled texture.

The red bird on the white background has been drawn on velour paper. It has an even surface, with no pattern or irregular texture. The tex-ture of this paper is a bit rougher than that of the suede board, which seems much smoother to the touch.

You can see how both papers help create and replicate the softness of the birds. By using a lighter touch on certain areas, such as the red bird's belly, the paper comes through, giv-ing the illusion of fluffiness. Because the pigment of the pencils remains on the outer surface of the paper, it is also possible to lift light areas out with a kneaded eraser. It is very user-friendly. Do not, however, use the typewriter eraser. This will damage the knap of the paper.

Extremes, such as burnishing or using white on dark paper, do not work very well with these papers. Burnishing will destroy the surface of the paper if done over large areas. Also, white does not cover dark paper well. It has a tendency to become flaky looking. If there is a lot of white in your drawing, start with a white paper and let the color come through instead of adding it.

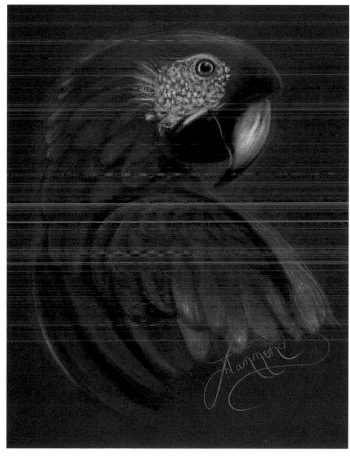

POLLY
Prismacolor pencils on
Garnet suede mat
board
8" x 10" (20cm x 25cm)

COLORS USED

Poppy Red, Crimson Red, Tuscan Red, Canary Yellow, True Blue, Black and White.

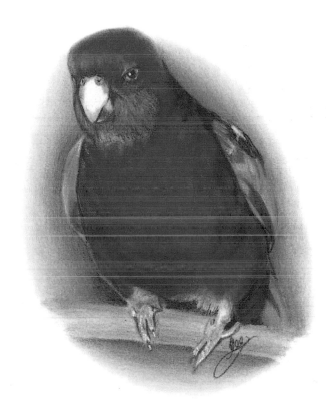

STUDY IN RED
Prismacolor pencils on
White velour paper
8" x 10" (20cm x 25cm)

COLORS USED

Bird: Crimson Red, Tuscan Red, True Blue, Ultramarine Blue, Yellow Ochre, Black and White.
Background: True Green, Dark Green, Indigo Blue and Deco Aqua.
Branch: Yellow Ochre and Light Umber.

This little kestrel has a very soft appearance. Although there is a lot of color here, I used White velour paper, allowing the white of the paper to come through in the drawing. To achieve the dark background, I used many layers of Indigo Blue and Black to cover the White paper. Patience is the key here, since you have to use a light touch.

COLORS USED

Bird: Sienna Brown, Terra Cotta, Henna, Yellow Ochre, Indigo Blue, Ultramarine Blue, Blue Violet, Aquamarine and Black.
Background: Indigo Blue, Dark Green and Black.

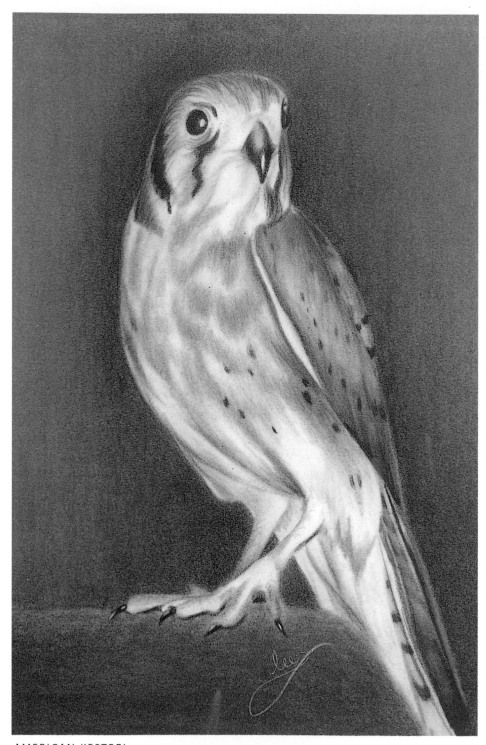

AMERICAN KESTREL
Prismacolor pencils on White velour paper
10" x 14" (25cm x 36cm)

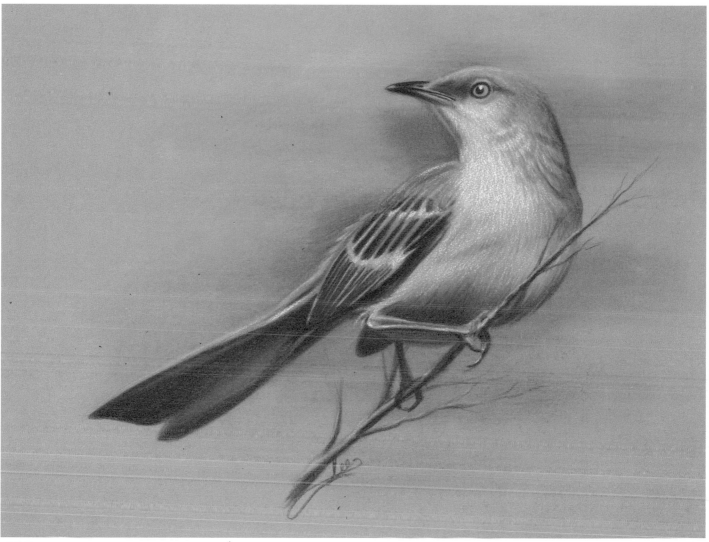

This mockingbird shows an example of what happens when you try to apply white on a dark background. This was drawn on a tan piece of velour paper. The White pencil on top of it has a grainy look. If this were supposed to be a smooth surface, this would definitely be a problem. However, due to the texture of the bird's chest, it actually helped create the look I wanted. I added various shades of blue into the background to separate the coloration of the bird from the tan background.

COLORS USED

Bird: Dark Brown, Burnt Ochre, Light Umber, Yellow Ochre, Terra Cotta, Black and White. (Notice the grainy appearance of the White.)
Background: Periwinkle, Aquamarine, Deco Aqua and Cool Gray 50%.

MOCKINGBIRD
Prismacolor pencils on Tan velour paper
9" x 12" (23cm x 30 cm)

Drawing a White Hawk Step-by-Step

We will be using the photo and graphed drawing of the white hawk from page 32. As I mentioned before, you cannot graph your drawing on the suede board or velour paper. Those surfaces texture, cannot be easily erased. Remember though, light highlights can be lifted with a kneaded eraser. For this project we will be using White suede board.

Earlier, I had you graph this drawing on a piece of copy or typing paper. Now, to transfer this drawing to your suede board, you must create your own carbon paper. Take your graphed drawing, and tape it drawing side down on a lightbox, sunlit window or television screen. You should now be able to see your drawing shining through.

With a dull no. 2 pencil, trace your drawing with dark, bold lines. Be sure to draw everything. When you are finished, flip the drawing over and gently position it over your suede board. Do *not* move it around very much, as this will cause the graphite to smudge all over your paper. Tape the paper down firmly.

With a sharper pencil this time—but not so sharp it will poke through the paper—redraw the image. Press hard enough to transfer the graphite from the other side onto the suede. You should now have a good line drawing transferred onto your paper. An alternative is to use an opaque projector. This will cast the photo's image onto the paper, allowing you to trace the outline.

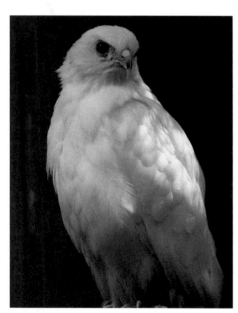

Photo of a white hawk.

COLORS USED

Black, Cool Gray 50%, Yellow Ochre, True Blue, Cool Gray 70% and Cloud Blue.

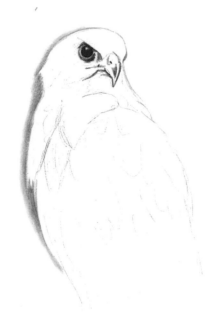

1 Start with the eyes to capture the essence of the bird, making it appear lifelike right away. For this, use only Black. Lightly sketch in some of the details of the beak area. Because this is a white bird on white paper, add some shading along the left side with Cool Gray 50% to separate it from the background. Be sure to use a very light touch for this; you do not want to see pencil lines.

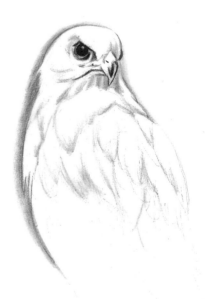

2 With the Cool Gray 50%, develop the feather patterns on the chest and wing of the hawk. Add some color to the background on the right side of the bird.

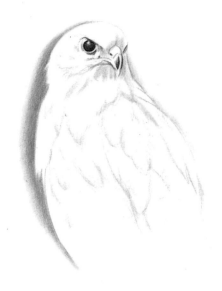

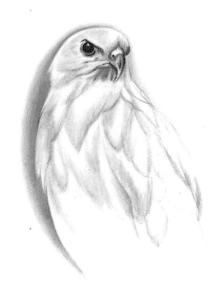

4 Add some True Blue into the chest feathers and onto the top of the head. Add some to the beak area also. With Cool Gray 70%, add more darkness under the beak and onto the wing tip.

3 Add a light layer of Yellow Ochre over the wing area on the right. Place a small amount into the front of the face as well. With True Blue, go over the Cool Gray 50% and extend the background color. Again, be sure to use a light touch.

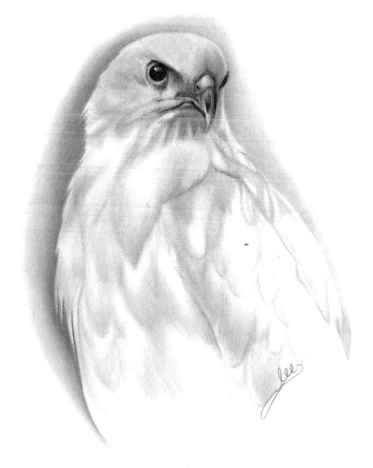

5 To finish the hawk, soften the colors of the bird by layering Cloud Blue over the colors. This will make the other colors look less harsh. Also add Cloud Blue to the background. This is a good example of how a great drawing can be done with very few colors.

Blending With Studio Pencils

We have seen how various brands of colored pencils combined with different paper types can produce a variety of looks. There is one more brand that can be very versatile, producing soft, gradual color as well as deep, rich hues. This brand is called Studio pencils by Derwent. Studio pencils are clay-based instead of the wax type like Verithin and Prismacolor. This clay formulation makes them perform differently. Derwent also makes a thicker version of these pencils, called Artists pencils.

Look at the value scale to the right. Notice how it is extremely dark and opaque at the beginning and fades into the white of the paper at the end. The first part of the scale has been applied with firm pressure, or burnished. The second half of the scale has been applied very lightly and then blended with a tortillion.

When using Studio or Artists pencils, you need to remember one thing: When they are applied lightly to the paper, they will blend beautifully; if they are applied heavily, they will not. This drawing of a flamingo is a good example of both applications. Look at how dark and filled in the tip of the beak appears. I had no problem at all creating its rich, smooth surface with Ivory Black and Chinese White. The eye was filled in with a firm application of Chrome Yellow.

Now look at how soft the rest of the bird looks. To achieve this effect, I applied the colors very lightly, and blended the tones out with a tortillion. The color of the bird was created with Pale Vermilion and Deep Vermilion. I also used Burnt Carmine for the deep purplish tones seen in the nostril area, the shadow area on the beak and the shadow edge of the head and neck. The background was created with Bottle Green and Aquamarine.

A value scale drawn with Studio pencils.

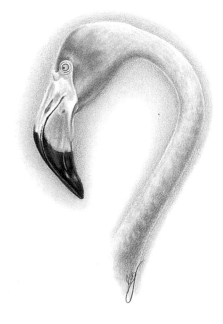

COLORS USED

Bird: Pale Vermilion, Deep Vermilion, Burnt Carmine, Chrome Yellow, Ivory Black and Chinese White.
Background: Bottle Green and Aquamarine.

This flamingo is an example of what can be done with the Studio pencils, using both techniques as seen in the value scale above. To help create the fuzzy texture of the flamingo, I chose the Cotman watercolor paper for this drawing.

FLAMINGO
Studio pencils on Cotman watercolor paper
12" x 16" (30cm x 41cm)

Blending Backgrounds

The blended technique can also be done on a colored background. These bluebirds were drawn on a mat board called Candlelight no. 908. It has a warm beige color. By using a toned background, the white areas of the birds stand out more. This blended technique combined with the heavy application of deep colors gives this method a high degree of realism. The contrasts in this drawing make it very impressive. The deep shadow seen inside the log,

as well as the darkness seen on the birds, makes the light source in this picture very obvious. By blending some blue into the background, you get the feel of the sky behind them.

This goldfinch was also drawn on a toned paper called Renewal paper by Strathmore. It, too, has strong contrasts between the soft, pale colors and extreme black. The soft addition of Turquoise Blue into the background finishes the drawing, which is now a nice composition.

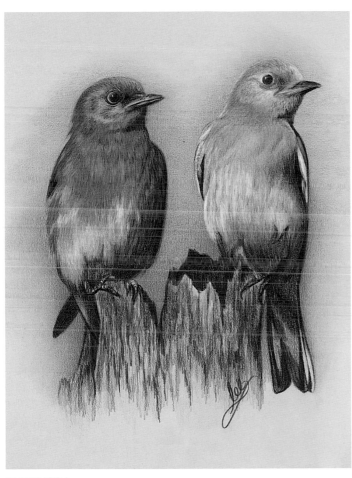

BLUEBIRDS
Studio pencils on no. 908 Candlelight mat board
10" x 12" (25cm x 30cm)

GOLDFINCH
Studio pencils on Renewal paper
9" x 12" (23cm x 30cm)

Working With Dark Backgrounds

The other wonderful characteristic that Studio pencils and Artists pencils have is that they can also be used on dark or black paper. Their pigment is opaque enough to cover the paper surface. But, unlike the Prismacolor examples on black that we saw on page 59, these pencils can be blended, for a softer look.

This drawing of a robin and her offspring was created on Artagain paper in Gotham Gray. I was able to blend the blue tones into the gray color, creating a subtle background. Had I used a white paper, the background would have been too bright. By using the darker paper, the white areas of the drawing are more dramatic, creating a more realistic look.

This drawing of a blue jay is another one of my favorites. It was done on a piece of Smooth Black mat board no. 921. I love the way the black background makes the white stand out in the drawing. I also think the way the blue blends into the black in the background is a beautiful look. Compare this look to the rooster on page 59. Both of these drawings have similar features, but they look completely different due to the paper texture and the brand of pencils used to create them.

ROBINS' NEST
Studio pencils on Gotham Gray Artagain paper
9" x 12" (23cm x 30cm)

COLORS USED

Birds: Deep Chrome, Burnt Sienna, Middle Chrome, Burnt Carmine, Steel, Silver Gray, Ivory Black and Chinese White.
Nest: Gold, Chocolate, Ivory Black and Chinese White.
Background: Bottle Green, Jade Green, Turquoise Blue, Indigo Blue and Ivory Black.

BLUE JAY
Studio pencils on no. 921 Smooth Black mat board
8" x 10" (20cm x 25cm)

Drawing a Seagull Step-by-Step

Now that you have seen what these pencils can do, let's draw the seagull together. Use the line drawing you created from page 33.

Study the original photograph, and make sure that you have all of the details as accurate as possible.

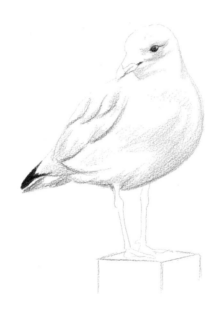

1 With Ivory Black, draw in the eye. Also fill in the tip of the tail. Lightly develop the shapes of the wing and tail feathers. With Steel, add some shadows to the belly of the bird, as well as the eye area and neck.

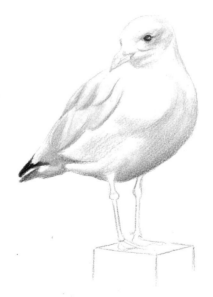

2 With Gold, lightly add some color to the beak. Now, with a clean tortillion, blend the gray tones of the drawing until they appear smooth. When your drawing looks like mine, proceed to the next page.

COLORS USED

Bird: Ivory, Black, Steel Gold, Bottle Green, Olive Green and Copper Beech.
Background: All previous colors used, applied horizontally and blended out.
Wood post: Copper Beech and Ivory Black.

3 To create the green color of the bird, which is the color background reflecting off the feathers, lightly add Bottle Green to the chest and belly. Also apply a small amount to the wing feathers. Blend this color out with the tortillion, allowing it to soften into the gray color already there. Then add a brighter green above the leg on the left, and blend it with Olive Green. Also placed some Olive Green into the leg itself. Finish the beak by blending the Gold, and adding the Ivory Black details.

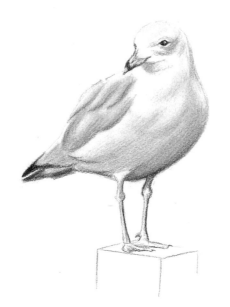

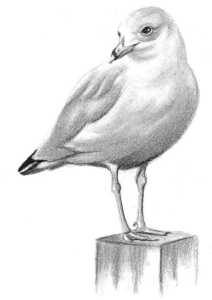

4 Now add some brown tones to the bird with Copper Beech, placing them in the top of the head, the wing and the chest. This color also blends into the existing colors, giving the entire drawing a soft look. Finish the legs and feet by blending the Olive Green and adding the Ivory Black for the details. Start to draw the wood post, using Copper Beech and Ivory Black. Use vertical pencil lines to mimic the grain of the wood, and blend it lightly to soften.

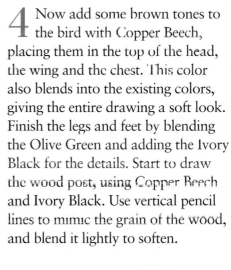

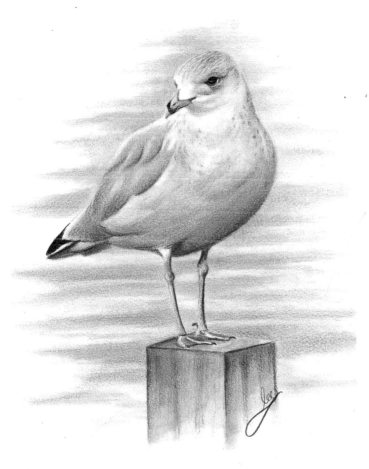

5 To finish the seagull, draw in the speckles and patterns on the head and chest with Copper Beech again. Add more Copper Beech to the wood post, and blend again. Repeat all of the colors previously used to create the illusion of water behind the seagull. Use a horizontal application, layering the colors on top of one another. Then blend all of it out with the tortillion for a soft, subtle look.

Watercolor Pencils

There certainly is more to colored pencil than meets the eye. There are so many different looks that can be captured. But who would have ever thought that you could create a *painting* with colored pencil? You can with watercolor pencils.

Actually, watercolor pencils have been around for the last thirty-five years. They just weren't very popular in the fine art community. They were marketed more for schoolkids, for mapmaking and such. But now they have taken the art field by storm.

There are quite a few brands on the market today, and all of them are very good. For this book and my own personal use, I have used both Derwent and Prismacolor. I think Prismacolor is my favorite brand.

Watercolor pencils are just what the name implies: pencils with lead made of actual watercolor pigment. Drawn on paper, they look like ordinary colored pencils and actually feel a lot like the Studio pencils. They can be used dry, like regular colored pencils. But with the addition of a little water and a damp paintbrush, magic can occur, turning your drawing into a beautiful watercolor painting.

WATERCOLOR VALUE SCALE

The value scales on top are drawn with watercolor pencil. They look very much like those of any other colored pencil.

The bottom illustrations show what the value scales look like with the addition of water. When drawn lightly, the wash produced is very transparent and fluid. Now look at the difference when the colors are drawn dark in the dry stage; they become even darker when wet. Keep this in mind in the drawing stage so things don't get out of control when you add the water.

These value scales have been applied in dry form. The one on the left is a light layer of pigment; the one on the right has been applied heavily.

Here are the same value scales with the addition of water. The one on the left, which was applied lightly, now looks like a light wash. The one on the right, with more pigment, now looks more like opaque paint.

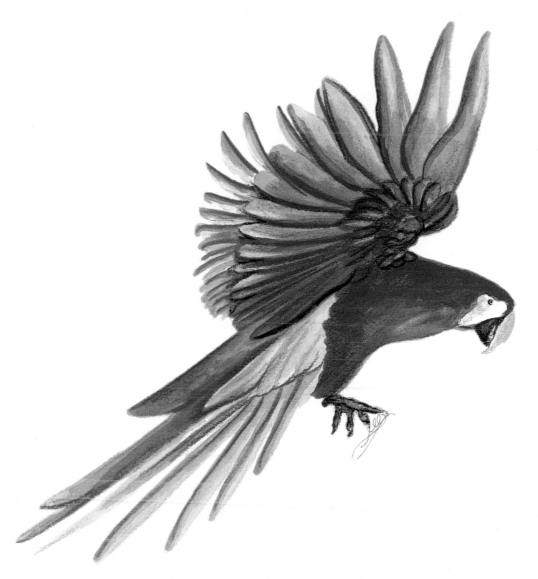

A PARROT IN FLIGHT
Watercolor pencils on Cotman watercolor paper
9" x 12" (23cm x 30cm)

This is an example of a watercolor pencil drawing/painting. Study it closely and you can see where part of it looks like a drawing while the other parts look painted. It is a nice combination of techniques that results in a unique appearance.

COLORS USED

Poppy Red, Crimson Red, Carmine Red, Dark Brown, Non-Photo Blue, True Blue, Peacock Blue, Copenhagen, Ultramarine, Indigo Blue and Black.

Drawing a Swan Step-by-Step

Watercolor pencils are handled completely different than other colored pencils. They require a whole new method and application to properly use them. This simple project will give you some practice using the watercolor pencils. Use the line drawing of the swan from page 34.

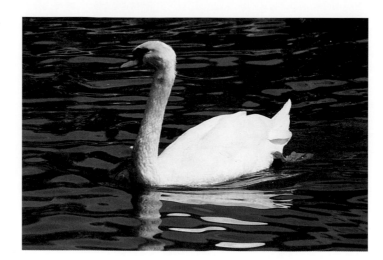

Study the original photograph and make sure your line drawing is accurate.

1 With watercolor pencils, I like to start light. It is easy to add more tone later, but nearly impossible to lighten something once the water has been applied. So with that in mind, start with the background, and lightly apply True Blue into the water area using a horizontal stroke to create the illusion of water. Then add some Goldenrod lightly to the shadow edge of the swan's neck and head, as well as the back, chest, tail and foot. Also add some to the swan's reflection in the water.

2 Add the pattern above the bill with Black, and fill in the bill with Orange. Colors become much darker and brighter once the water is added, so you do not have to use much pencil here. With a damp paintbrush, wash out the blue in the water area, turning the drawing into a painting. Clean your brush, then go over the Goldenrod on the bird and in the water. Wait for this stage to dry. This is very important! If you draw with the watercolor pencil into a wet area of the paper, the pigment of the pencil melts into the paper, creating a very dark line that will not blend out with water. Be sure to let the areas dry before drawing in more tone.

After the painting is dry, add some Cool Gray 50% to the shadow edge of the neck, the back near the wing, under the foot and into the reflection in the water.

COLORS USED

Black, Orange, Goldenrod, True Blue and Cool Gray 50%.

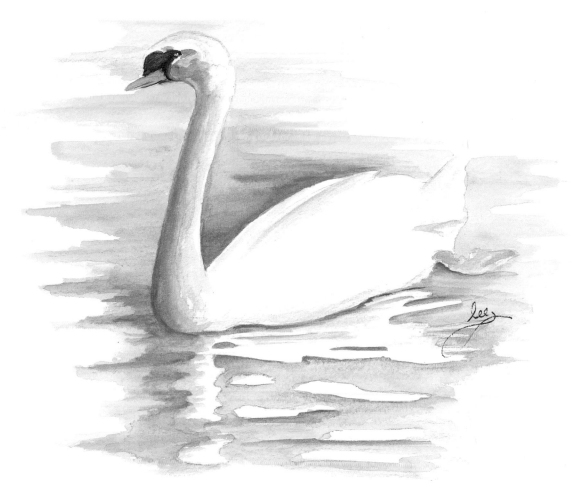

3 This is the stage of the project that I like the most, where the drawing is treated more as a painting. Take a damp paintbrush to the areas where you have drawn in more tone. Then start to enhance the painting with a technique I call "borrowing." Borrowing consists of taking the wet paintbrush and swiping it across the tip of the watercolor pencil—this action transfers pigment onto the brush, allowing you to then paint it directly onto your work like a regular watercolor. This stage is done with the paper already dampened.

Now is when you'll really develop the tones. Using the borrowing method, increase all of the tones in the painting. Can you see how much brighter the colors are now? Look at how the white reflections in the water stand out against the blue tones. The shadow along the neck is much more pronounced. Soften the colors of the face also with a damp brush so that it matches the rest of the painting.

THE END

Conclusion

As you can see, there are thousands of birds you can choose from to draw. You will never run out of possibilities. There are also many ways to capture them on paper. I have only shown you a handful of the hundreds of techniques.

Now it is up to you to determine how far you really want to go. Practice is the essential key to doing anything with skill. I know firsthand how difficult and frustrating it can be. Being self-taught, I've made many "messes." I will make plenty more throughout my life. It may appear to some that everything I do turns out looking suitable for framing. Not so! I always tell my students that I have two trash cans in my studio at all times, and they get used on a regular basis.

What I'm saying here is not to be afraid to make some mistakes. They aren't really mistakes after all, just experiments with a result that looks good or not. How else will you find out if something works? I learned the beautiful technique of Prismacolor on velour purely by accident. If I had played by the books, I never would have developed my technique! Have fun, and experiment with as many methods, techniques and tricks as you can. The more you draw the better you will be.

I hope you will continue to allow me the opportunity to be your guide. More books on these techniques are on the way. Good luck to you always!

Sincerely,
Lee Hammond

Index